The Artist's Guide to
PERSPECTIVE

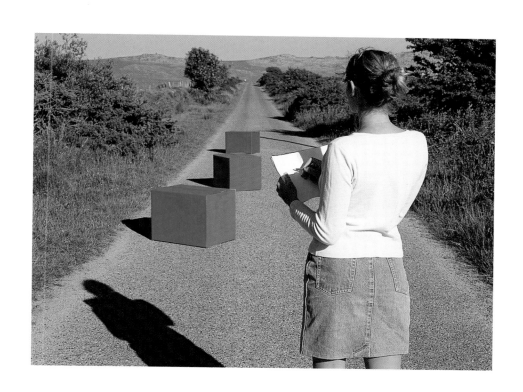

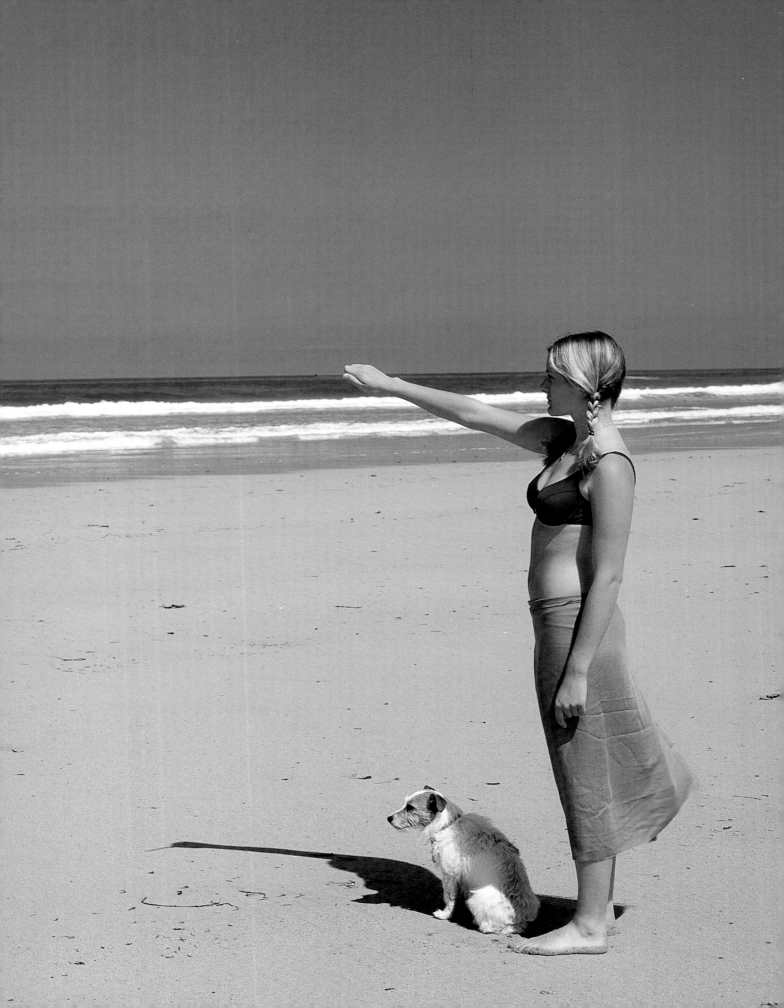

The Artist's Guide to
PERSPECTIVE

Janet Shearer

NEW HOLLAND

DEDICATION
This book is dedicated to my children, Doon and James who posed, with Flossie, the Jack Russell and Sooty,
my horse, for some of the photos, and had wonderful patience with me while I was writing it.

Published in 2003 by
New Holland Publishers (UK) Ltd
London • Cape Town • Sydney • Auckland

Garfield House
86–88 Edgware Road
London
W2 2EA
United Kingdom
www.newhollandpublishers.com

80 McKenzie Street
Cape Town 8001
South Africa

Level 1, Unit 4, 14 Aquatic Drive
Frenchs Forest, NSW 2086
Australia

218 Lake Road
Northcote, Auckland
New Zealand

ISBN 1 84330 345 0

Senior Editor: Clare Hubbard
Designer: Sara Kidd
Photographer: John Freeman
Production: Hazel Kirkman
Editorial Direction: Yvonne McFarlane

1 3 5 7 9 10 8 6 4 2

Reproduction by Modern Age Repro House Ltd, Hong Kong
Printed and bound by Tien Wah Press, Singapore

Picture credits

Pg 5 (bottom left, top right), 13 (bottom right), 32, 34, 36, 41,
44, 52 (top), 56–57, pg 58, 60 (top right and bottom), 64 (centre), 66–67,
75 (top left and bottom), 79, © John Freeman.

ACKNOWLEDGEMENTS
I'd like to thank my sister Gillian for all her help with the book and for teaching me what I know about perspective in the first
place. Huge thanks to Helen Terry for her kindness and support during the time spent creating the book, and to Clare Hubbard
and Sara Kidd for their expertise and patience beyond measure when things got tense! Thank you to John Freeman whose
photos have made an apparently dull subject bright and colourful. Thanks also to those people whose houses we
photographed. Lastly, I'd like to thank Yvonne McFarlane who gave me the chance to do this book which, although difficult,
will I hope help artists who, like myself, are not very technical!

Contents

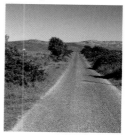

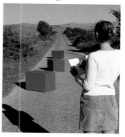
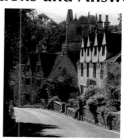

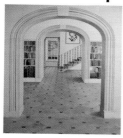

Introduction

The amazing thing about perspective is that we live with it every day. Our brains neatly sort out images supplied by our eyes and put things into a sensible, logical and acceptable order for us all the time. Most of us never even question what we are looking at. Things that are further away seem smaller, maybe fainter in colour, perhaps a different shape compared with the same object perceived from another position, but why would that concern us? We don't really need to think about it because it's all done automatically to give us the chance to go through life with some perceptions of reality and to stop ourselves bumping into things.

If you are reading this then you must already have an interest in perspective. Although you are not necessarily an artist, I'm presuming that you would like to think a little more about what you are seeing. Who knows? Even though you have never felt inclined to sketch before, perhaps you will want to have a go if you feel you have the knowledge that you need to do so.

Perspective is the key to successful drawing and painting, yet it is a subject that many people find very daunting. Why? The first problem with perspective is the word itself. It sounds so spiky! Doesn't it sound like 'prickly', 'strict', 'respect', 'correct'? All the things that gentle and sensitive artistic types absolutely hate. The dictionary definition of perspective makes frightening reading. I'm sure that any gentle minded person would run a mile if they thought that they were supposed to comprehend its meaning. Try this, for example: "Perspective: The art of delineating solid objects upon a plane surface so that the drawing produces the same impression of apparent relative positions and magnitudes, or of distance, as do the actual objects when viewed from a particular point." We really need a simpler definition. We like things that are comfortable, peaceful and intuitive, and are likely to switch off our minds completely if something looks as though it's going to involve a lot of straight lines, discipline and, worst of all, maths!

Although able and keen to draw, I had very little real information on the subject of perspective prior to beginning my mural painting. It seemed to be completely avoided during my fine art studies or perhaps I just wasn't listening because it was too difficult and too boring! However, I soon realised when I started to undertake commissions for murals that I would not be able to do my job properly without acquiring a basic knowledge of perspective. Whilst struggling to find out what I needed to know, I realised that most perspective books were written with the sort of technical approach almost bound to put someone like myself off the subject forever. So, this inspired me to write my own book on

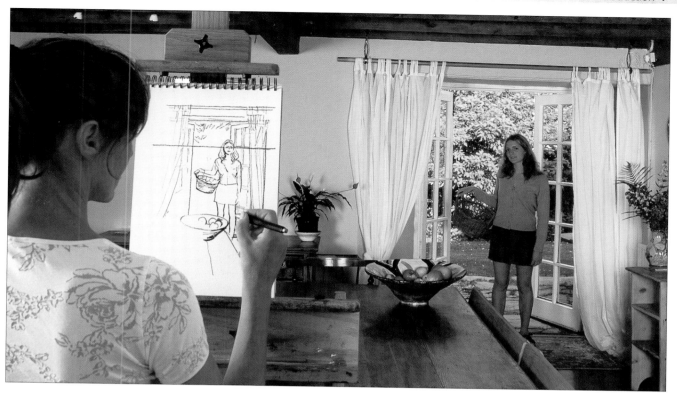

the subject, to save other artists from difficult technical explanations and complicated diagrams. My book takes a light-hearted, softer, more artist-friendly approach to explaining how the whole subject relates to figurative (realistic) drawing and painting. It is based on the way I teach perspective during my mural painting courses and has proven to be successful and easy to grasp by my pupils.

The first part of the book is about observation and understanding. It's important to realise that although you may not consider yourself to be an artist, having an understanding of what you see could lead you on to a little sketching in the future, should you find yourself with time on your hands and a pencil and paper within your reach.

Great happiness can be found in the pursuit of achievable goals, and believe me, drawing and painting with the benefit of some sound knowledge, method and consistency can

become an achievable goal! Although one doesn't want or expect to produce an identical copy of the chosen subject, being able to interpret artistically, with intelligence, what we can see involves a process of understanding and learning with almost no boundaries. The personality and individuality of the artist can only be enhanced by adding quality to the work which naturally follows the application of knowledge. As you read the book, you may find that although you had never seen yourself as the artistic type, your confidence will grow and you may feel like having a go at drawing with lines and painting with colour. I hope the book will help you to enjoy the exploration of new territory and perhaps have a little more confidence than you did before.

Janet Shearer

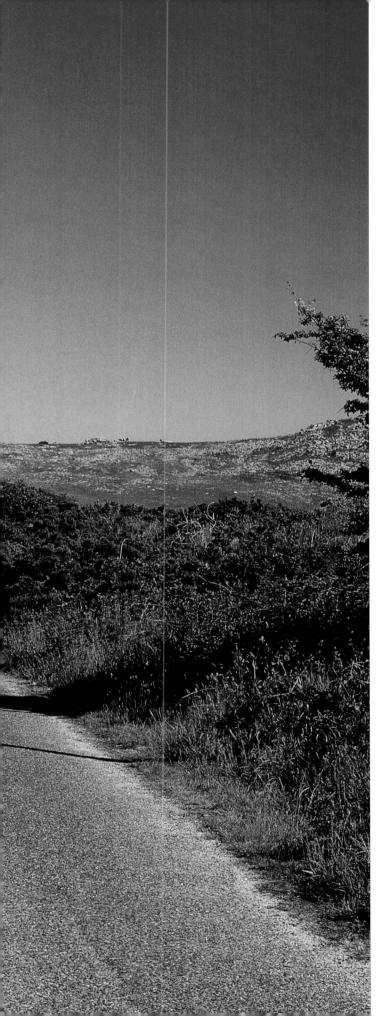

How Perspective Works

Anyone with a general interest in art can use simple observations to develop their drawing skills. A good way to gain a basic understanding of perspective is to take yourself to a beauty spot in the countryside – maybe you could go for a picnic or take the dog for a walk – and find yourself a long stretch of straight road. Make sure it is fairly remote, as you are going to need to stand in the middle of it to complete a series of practical exercises.

Where I live, it's almost impossible to find a road which runs into the distance in a flat landscape. However, for the purposes of this book, this moorland stretch is the nearest we have locally to a long straight road on which to demonstrate the basic rules of perspective.

Exercise 1: Finding the horizon

The basic lessons you will learn through this exercise are that the position of the horizon in your view is always dictated by your eye-level and on a straight, flat road, the sides of the road will always appear to converge at your eye-level.

Start to plan your expedition. Firstly, you need to find the right location – a long straight road without any cars on it. I found my ideal location on a nearby deserted moorland road. It is not as perfect as a long trans-prairie road in North America, but it will serve our purpose. You will need to take a pencil with you – all will become clear as you work through the exercises. Working through these steps will encourage you to really get to grips with what you are looking at. If you can't find a suitable location, just look at the photographs carefully and use your imagination.

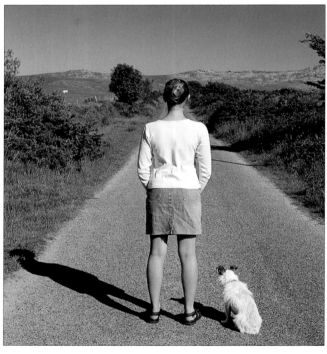

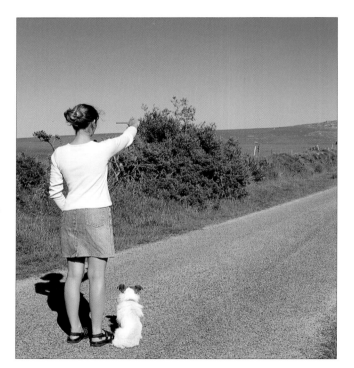

1 Stand in the middle of the road, with your eyes and feet pointing straight ahead of you. Don't stand with your feet showing ten to two on the clock because it ruins the experiment! Keep your eyes level: in other words, don't look up or down. Think hard about what you can see in front of you. The spot on the road where you are standing is called **the viewpoint**. You will notice that the sides of the road appear to converge in the distance, which is odd, because they are clearly parallel to each other. You have just discovered perspective for yourself!

2 Still standing in the middle of the long straight road, hold your arm in front of you and extend your thumb out from your closed fist as if you were doing a 'thumbs up' sign. Instead of the thumb pointing upwards, turn it sideways so that it forms a relatively straight line horizontally in front of your eyes and at your eye-level. Holding a pencil at this angle makes a slightly longer and straighter horizontal line. If you are not an artist, you may have wondered what artists were doing with pencils stuck out at arm's length – now you know.

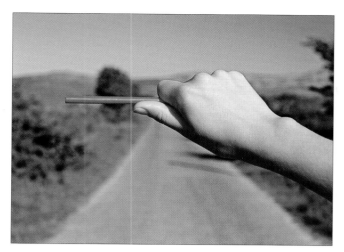

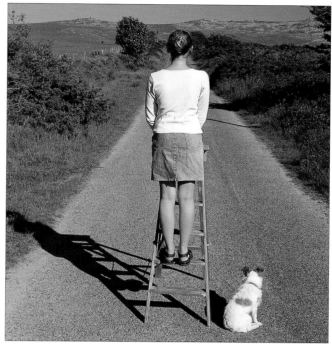

3 Your thumb/pencil should be level with your eyes, which in a flat landscape will be level with the horizon. However, if you have any distant hills, tall trees or buildings in your view as we have, these may rise above your thumb/pencil – in other words, above your eye-level. Now look past your private horizontal line to the point where the sides of the road appear to converge. **In a flat landscape, you will see that the sides of the road appear to converge at your eye-level,** which for an average height adult is about 1.5m (5ft) when measured from the ground to the eyes. This is an invaluable revelation! For future reference try to remember that your feet are also parallel to your direction of view provided that you are not standing like a ballerina/Charlie Chaplin/a penguin.

4 If you had brought a small step ladder with you, you could climb up it so you are standing in a much higher position on the road than before. You would see that the horizon has followed your example and has risen with you. It would still appear to be at your eye-level but the angle at which the sides of the road appear to converge has changed.

5 By now you may have had enough of all this thinking, but if you can face one more part of the experiment, sit down (or crouch if the ground is wet and muddy). You should still be in the middle of the road and have your arm outstretched, with your private horizontal line in front of your eyes. **Magically, you will see that the sides of the road still appear to converge at your eye-level** – even though the horizon seems to have gone down with you – but that the sides of the road converge at a more dramatic angle than before.

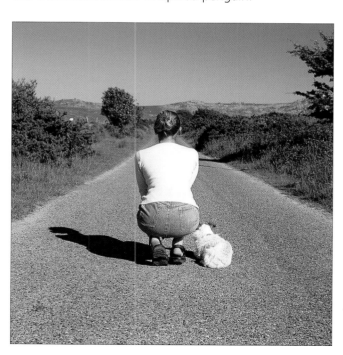

Exercise 2:
An appreciation of eye-levels

This exercise will help you to notice where your eye-level is and also to understand the relationship between your eye-level and other people in your view. It also gives you the perfect excuse to spend the day at the beach. Equipment you will need? Pencil, picnic and swimming costume.

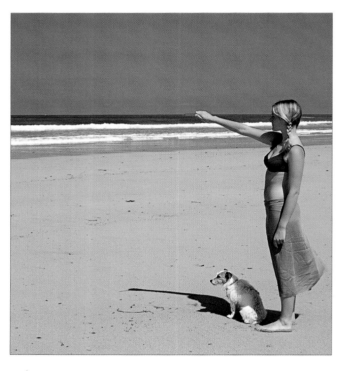

1 Stand on a beach facing the sea. Adopt the same stance as in Exercise 1 (see pages 10–11) i.e. standing, feet and eyes to the front, and arm outstretched with thumb or pencil horizontal. **Look past your thumb/pencil and you will see that the horizon appears at your eye-level.**

2 If there are other people on the beach, turn your gaze sideways to look at someone of roughly your own height who is standing on the beach at about the same distance from the sea as you. If you can do this without upsetting anyone, with your usual thumb/pencil technique, **you will see that their eye-level is at your own eye-level.**

3 When someone walks away from you down towards the sea you will see that their head begins to drop below the horizon – your own eye-level – because the ground level is sloping downhill away from you. **It's worth remembering that a person or an object of the same height as you drops below the horizon when the ground is sloping away from you.**

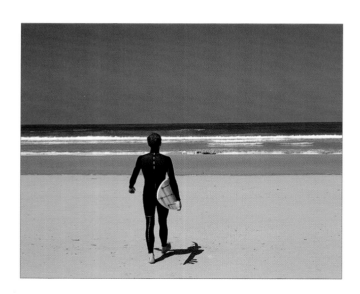

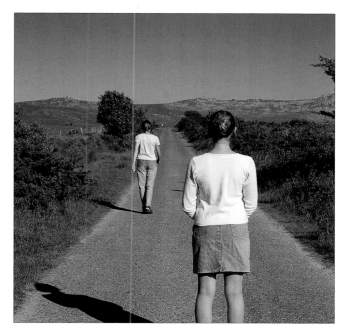

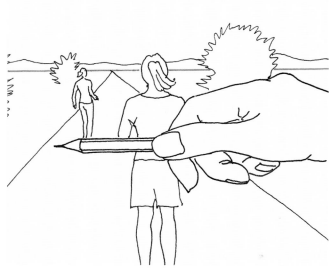

4 By way of comparison, if you observe two people in the middle of a long, straight road in a flat landscape, one further away than the other, what you notice is that, **although the person appears to get smaller in the distance, the position of their eyes (or the eyes in the back of their head) stays at your own eye-level,** even though their feet seem to have climbed higher than the feet of the nearer person.

5 If you use your horizontal thumb/pencil line held under the feet of the person furthest away, you will notice that your pencil is level with the waist of the nearer person, even though both peoples' eyes have remained at your own eye-level.

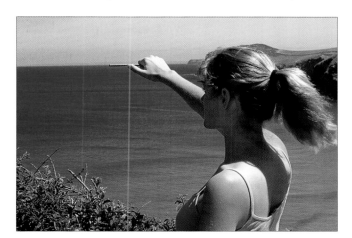

6 Climb the nearest cliff or building in search of a higher vantage point from which to see the sea. Take up your usual position. The horizon will have climbed with you in the same way as the horizon would have if you had climbed a ladder looking down the long, straight road. **Although you are above sea level and keeping your gaze steady and in front of you, the horizon will be at your eye-level as before.**

⌂ If you look down, almost from a bird's-eye point-of-view, your horizon would, of course, be way above your subject. On pages 78–81 there are a few ideas on how to draw people and animals from odd angles.

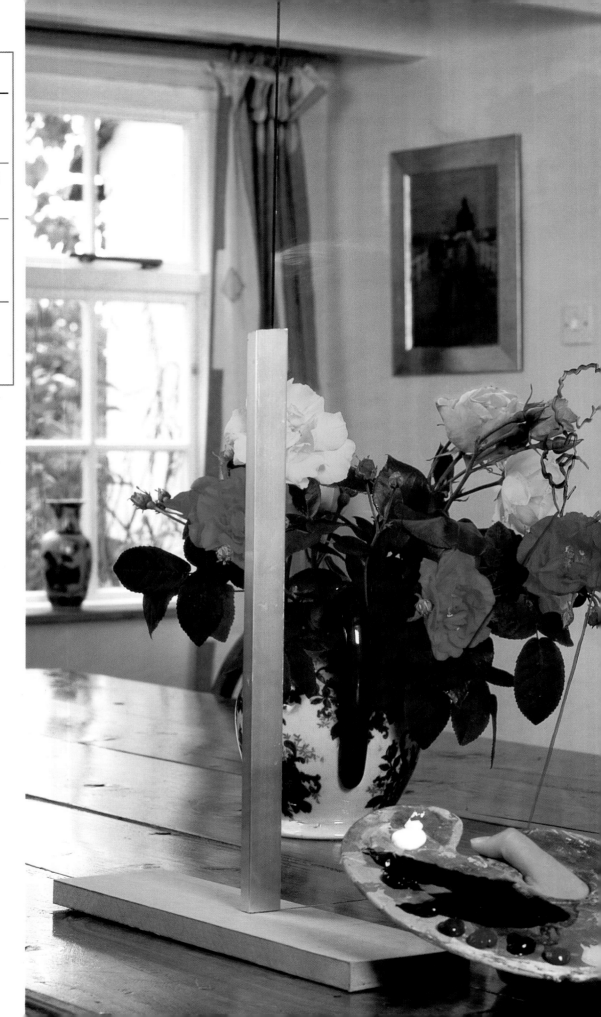

Key

Black lines: lines as viewed in real life

Red lines: eye-level

Blue lines: drawn lines on picture plane

Green lines: important 'construction' lines

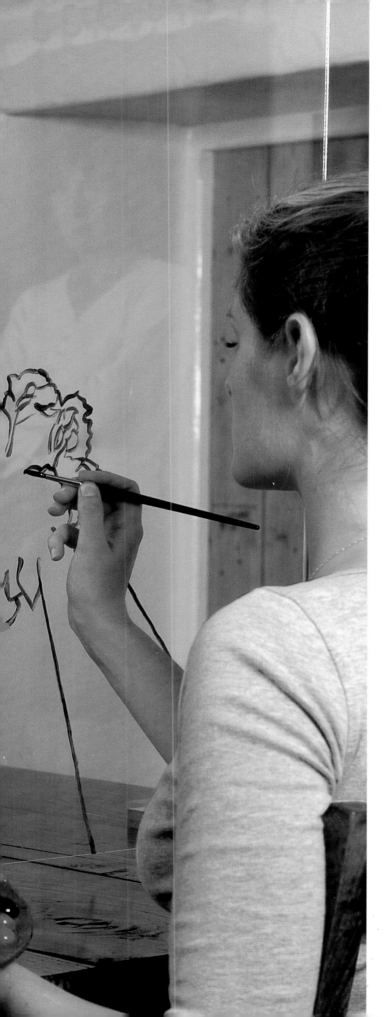

The Picture Plane

The picture plane is the surface on which you choose to draw or paint. In order to paint realistically, it helps to imagine that you have seen your subject through a piece of glass. This way, by making a few simple observations before you start work, you can position your subject carefully and use perspective in a considered way to give realism to your work. Using a real piece of glass and 'tracing' the outline of the subject makes it easy to demonstrate how this works.

Tracing a bunch of flowers on to a piece of glass mounted in front of you is clearly a ridiculous idea, but I use this simple teaching device to show how you can imagine the picture plane as a surface through which you observe your subject. The ability to correctly position lines which describe distance and space in your work is the fundamental art of perspective.

Exercise 3:
Establishing the picture plane

This exercise requires some imagination, so even if you think you haven't got any, give yourself a chance – you may be surprised! Its purpose is to show you what the picture plane is and how, by imagining that it is a piece of glass, it can help you to represent what you are looking at realistically. In your mind, travel back to the long, straight road. Look at the photographs on pages 10–11 to remind yourself.

Stand up straight as you did before, with feet to the front. (It sounds very military but it's good for you to stand up straight and slouching tends to drop your eye-level. It's better to be consistent from an artistic and a health point of view.) Now your imagination comes into play. Try to pretend that there is a huge, shop-window-sized piece of glass standing vertically in front of you, stretching across the road from side to side. Try to imagine that it is positioned at a short distance from you – a little more than arm's length away. Through the glass you can see the road disappearing into the distance.

By holding your arm outstretched and with your thumb/pencil extended sideways as

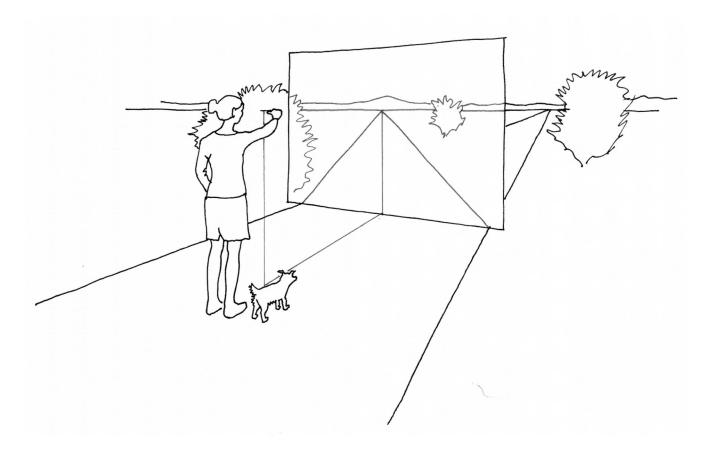

⌂ **The picture plane is the surface upon which you choose to draw or paint,** be it paper, canvas or, in my case, a wall. In art, it's as though you have seen your subject through a piece of glass and, by using the technique described above, you should be able to position important lines and angles upon this surface in order to make your subject look realistic. **Try to visualize this piece of glass every time you draw or paint, and trace the outlines of objects as you see them onto its vertical surface.** Even if the subject itself is in the distance and not vertical, this exercise helps enormously to 'see' shapes correctly.

before, you could, if you had some paint on the end of a long stick, mark your eye-level on the glass with a horizontal line. Leaving your original position (your viewpoint) and walking up to the glass would show you that the painted mark you had made was at your eye-level even when your nose was pressed against the glass.

Returning to your original viewpoint you could also, using the same imaginary but interesting technique, slap a bit of paint down the edges of the road to show the angle at which its edges appear to converge in the distance. Unlike the eye-level line, if you

changed your viewpoint – for example, by moving up close to the picture plane or stepping to the left or right – the painted sides of the road would no longer appear to be in the same position as the real sides of the road. The reasons for this will become apparent later in the book, but for the moment accept that when you move closer to the glass, the 'sides' of the road will appear to change.

Painlessly, you have begun to make the necessary observations in order to draw/paint in perspective! The glass represents the picture plane and you could draw what you have perceived through the glass in perspective.

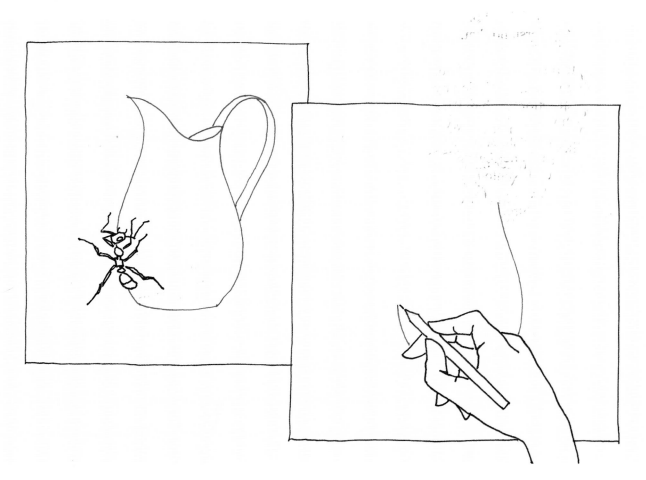

⌂ I often tell children to imagine the vertical glass between themselves and what they are looking at and then to imagine a remote-controlled ant walking across the surface of the glass, guided by their pencil on the paper. I tell them that by making the ant walk 'around'

objects on the glass, they are drawing. Children find this concept easy to understand and I won't say a word if you want to think of ants or laser beams following the lines or 'etching' the edges of the subject on the glass – basically, imagine whatever helps you.

Exercise 4:
The vanishing point

We have already discovered that if you stand in the middle of a long straight road, lines which are parallel to your direction of view – i.e. the sides of the road which are parallel to your feet – are shown on the picture plane as converging to a point in the centre at your eye-level. This point of convergence is called a vanishing point.

Establishing the position of this point on your eye-level can make the difference between drawing a masterpiece and giving up and going to the pub.

Another way of finding out about the vanishing point is to stand in the middle of a fairly uniform-shaped room, with your feet parallel to each other as before and face one wall. The position of your feet is very important in order to remind yourself of the direction of your view.

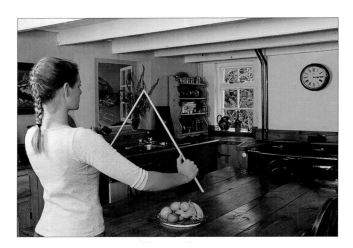

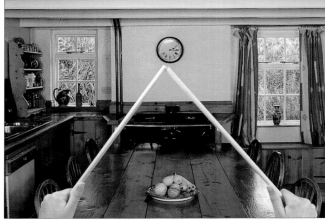

1 Hold a couple of straight sticks or long rulers in front of you as if resting on the vertical surface of the picture plane. Assuming that the room is square or rectangular, the walls at right angles to the wall you are facing should be parallel with your feet.

2 Angle the sticks towards each other at the top so that visually they rest on some lines which are parallel to your feet. **You will see that the sticks meet at a point in front of you, which is at your eye-level (as with the edges of the straight road).**

3 It's really important to keep the sticks upright as if they were resting on the vertical surface of the picture plane (see pages 16–17). Try not to tip them forwards or backwards. It's helpful to close one eye when doing this to avoid double vision!

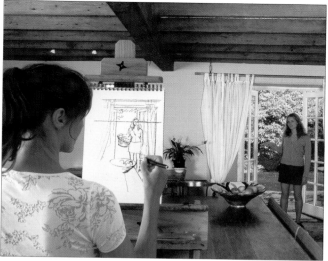

4 Do the same with the tops of the walls to your left and right, and you will see that these, too, appear to converge to the same point on the facing wall – at your eye-level. **The upper edges of the walls will be seen as lines that converge downhill to meet each other, while the bases of the walls will converge uphill to meet them.** You can now use this information to transfer the lines – for example the bottom edges of the walls – on to your picture plane (see diagram below). All you need to do is locate your eye-level on the picture plane and establish the angle of the edges of the walls when compared to a horizontal or vertical line.

5 This would be easy if the piece of glass was huge as you could measure from the floor to your eyes, doing the same on the picture plane. **When you are only doing a small painting, you have to 'eyeball' the position of the eye-level relative to the position and size of the walls in the scale of your work.** You are actually 'shrinking' the picture plane down to the size you want. This sounds complicated, but if you try to guess the height of the wall in your drawing, positioning the eye-level and drawing things in proportion to the height of the wall should be straightforward. If there's a doorway in the wall, ask someone to stand in it. Putting eyes into the figure will give you the right eye-level position.

◊ Any lines that form the edges of furniture, floorboards, bookshelves or rugs, which are parallel to your direction of view, are short lengths of lines that, if extended, would appear to converge at the same central vanishing point at your eye-level. Visualizing the picture plane in front of you, perhaps you could show these lines – for example, the top and bottom edges of walls – provided that you knew where your eye-level was on the picture plane. You might also be able to hazard a guess as to the angles created by the sticks compared with horizontal and vertical lines. Vertical lines and horizontal lines at right angles to them (but parallel with the picture plane) stay vertical and stay horizontal.

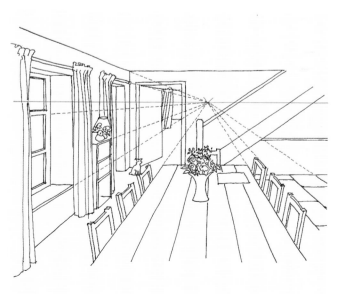

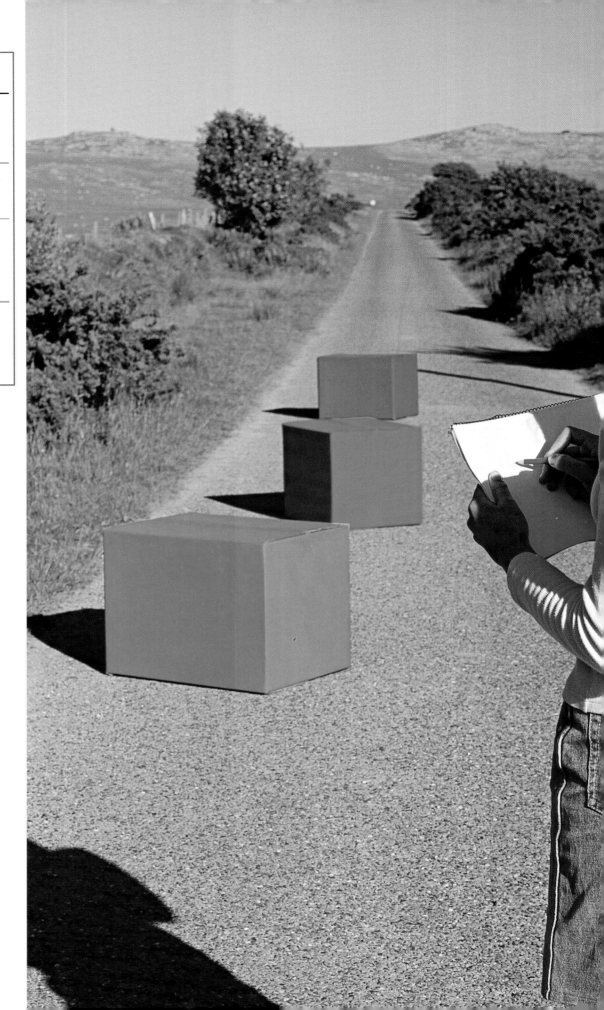

Key

Black lines: lines as viewed in real life

Red lines: eye-level

Blue lines: drawn lines on picture plane

Green lines: important 'construction' lines

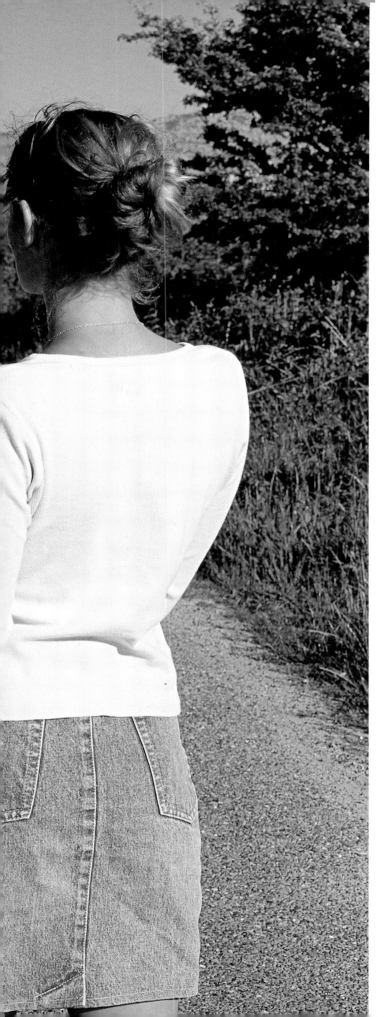

Vanishing Points

Having established a central vanishing point on the picture plane for all lines which are parallel to the direction of view, you can begin to consider what happens to lines which, although parallel to each other, are not parallel to the direction of your view. The purpose of the following exercises is to establish some simple guidelines to help you find vanishing points for cubic shapes, whether square or rectangular. This will help you to draw buildings with confidence.

Playing with some cardboard boxes and trying to work out how you can draw them in a considered way will help enormously when it comes to drawing buildings. After all, what are buildings, if not great big boxes?

Exercise 5:
Finding vanishing points

Return either physically or in your imagination to the stretch of straight road on level ground and take some large cardboard boxes with you. Position a box on the road, off-centre and at an angle to the sides of the road. Take a few steps back and stand in the middle of the road, feet parallel to each other and to the sides of the road, as you did before. Try to imagine the huge piece of glass – the picture plane. What you see now is the road with its sides appearing to converge to a central vanishing point. You can easily draw this because the central vanishing point is located on your eye-level, which is easy to position on the picture plane. If you are sketching this experimentally, simply put a line where you imagine the eye-level would be if the paper was glass and you were looking through it. Extend the line out to the sides as far as you can as shown in Step 3 (opposite).

What about the box? How do you draw that? Turn your left foot out until it is parallel with the left-hand side of the box. Raise your left arm and line it up with your left foot at eye-level height; point your finger. You are pointing to the vanishing point that will enable you to draw the left-hand edges of the box.

To help you to draw this vanishing point in position along the eye-level on your drawing (which is obviously much smaller than real life), use your pencil as a unit of measurement (see pages 24–25). Establish the centre of your field of vision (the area of your view), and

measure outwards from it to the newly discovered vanishing point as shown in Step 3. Sometimes the vanishing point you are looking for is off your paper. Just having a rough idea where it is will help to draw the box.

Now turn out your right foot and point with your right arm to establish the vanishing point for the right-hand side of the box.

All sets of parallel lines have their own vanishing points located at eye-level if the object in question is on a surface, which is level with that of the spectator.

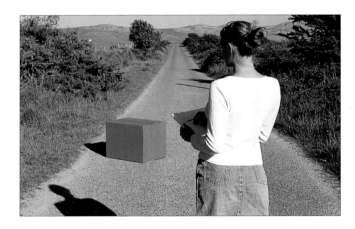

1 Place the box somewhere on the road, off-centre and at an angle to the sides of the road. Stand back from the box in the middle of the road.

2 Look down at your feet: they should be parallel to each other and pointing straight ahead of you. Look at the box. Now turn your left foot so that it is parallel to the left-hand side of the box.

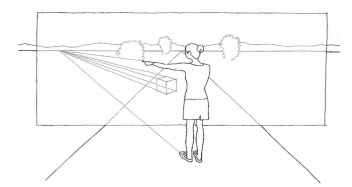

3 Line your left arm up with your left foot and point in that direction along your eye-level. This will lead you to a vanishing point that will help you to correctly draw the left-hand edges of the box when marked in.

4 Now turn your other foot out until it is exactly parallel with the right-hand side of the box.

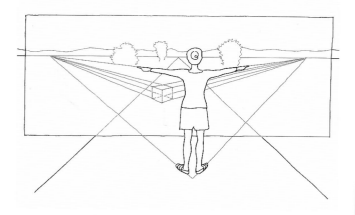

5 Line your right arm up with your right foot and point in that direction to a vanishing point that will help you to draw the right-hand edges of the box.

Alternative set-up

If you can't find a suitable road, you can conduct a similar experiment indoors – you just need a clear area of floor space. Lay two long, straight lines of tape on the floor about 3m (10ft) apart and parallel to each other to give the impression of a section of road. You can play with the cardboard boxes in exactly the same way as though you were on the stretch of straight road.

⌂ Stand at one end of the room in the middle of the two lines of tape and hold two sticks at arm's length (see page 18) as though they are resting vertically on the picture plane. If done correctly, when you point the upper tips of the sticks towards each other so that they meet at your eye-level, you will see that you can 'hide' the tape on the floor behind the sticks. It helps to have one eye shut for this. **This proves that lines in front of you, which are parallel to the direction of your view, appear to converge at your eye-level.** (It's very important to keep the sticks on the same plane as the imaginary glass and not tip them forwards.)

Exercise 6:
Judging proportion and distance

Whatever size your drawing is, the thing to remember is that it is important to look for relationships between objects as they appear on the picture plane.

Use your pencil as a unit of measurement (see Step 2, opposite, below), making comparisons of distances between the objects in front of you and remembering that you only want to know the distances as they appear on the picture plane – i.e. the imaginary piece of glass in front of you. Drawing should always be a series of comparisons made by you as you

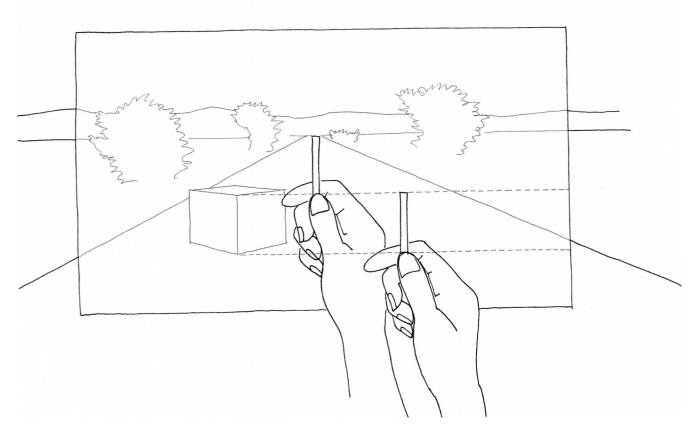

1 Try to judge the distance between yourself and the nearest corner of the box as perceived on the vertical picture plane, then compare this with the distance from that corner to the horizon. To measure this length quite accurately, hold your pencil vertically at arm's length. Try not to tip the pencil away from you as you must keep the picture plane in your mind. Move the pencil up and down until the top of the pencil appears to rest on the horizon (i.e. your eye-level). Slide your thumb down the pencil, holding it steady,

until it is level with the top of the nearest corner of the box. Fix the position of your thumb on the pencil and move the whole pencil downwards until the top of it lines up with the same corner of the box. Now observe where your thumb is. By picking a point on the road that is level with it, you can make an accurate measurement that will help you to position the box on the road. You have now established how to show the relative distance of the box from the horizon, which is a line that you are sure of.

progress towards a satisfyingly realistic sketch. Talk to yourself about it. It's a game of questions and answers with you doing both the questioning and answering. For example: is the box wider than it is high? Yes? This information will help your drawing.

Try to judge the distance between yourself and the nearest corner of the box as perceived on the picture plane – in other words, a vertical measurement. Using your pencil as a unit of measurement will help you to do this correctly.

All you need to do now is establish the position of the nearest corner of the box and its height. At this stage use a system which all artists use – 'eyeball' it – in other words, make an informed guess.

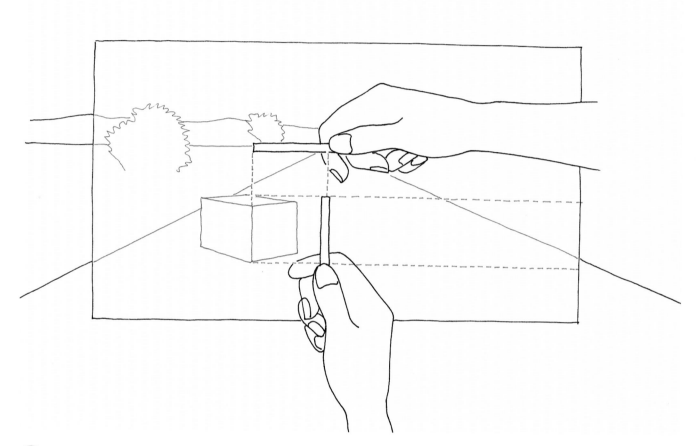

2 Using your pencil several times over to measure, ask yourself one or two simple questions to help determine distances on the picture plane: for example, how far from the centre of the road is the box located? Is it halfway between the centre of the road and the side? Or nearer the side of the road than the centre? **By using your pencil to compare the height of the box with the height of your eye-level, you will be able to sketch the box quite accurately, even if you have no previous experience of drawing.**

Exercise 7:
Vanishing points at, above and below your eye-level

If you had plenty of boxes and could stack them up in the road, one on top of the other, as shown in Step 1, observing what happens to the edges as they appear on the picture plane would be very interesting. You would see that the edges of the boxes still appear to converge to vanishing points on the eye-level and how an awareness of the angles formed by these edges describes in your drawing where the object is in relation to your eye-level – in other words, above or below, and by how much.

1 It's unlikely that you would feel like taking a pile of boxes to your chosen straight road, but we did in order to show what happens if you stack them up so that some of them are above the eye-level. It is still very easy, using the same method of lining up your feet with the side of the stack, to locate the vanishing points for your drawing on the eye-level line.

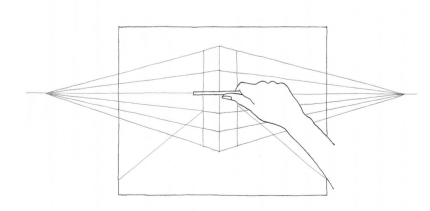

2 Hold your pencil at arm's length, horizontally along the horizon at your eye-level. **You will notice that the higher the boxes, the upper and lower edges of the boxes that are above your eye-level slope downwards towards the vanishing points at an increasingly steep angle. Meanwhile the edges below your eye-level slope up towards the vanishing points. Where a box sits level with your eye-level line, its horizontal edges appear in a straight line i.e horizontal.**

Exercise 8:
Three-point perspective

We have seen how you can use the horizontal edges of a subject to establish vanishing points. Now see what happens when you look at the vertical lines of a subject.

By drawing along the lines described in Steps 1 and 2 below, you are using a three-point perspective.

1 Go back to your tall tower of boxes. **If you look up at the tower from a low viewpoint, the sides appear to converge in the sky.** This way-up-in-the-sky vanishing point can be used to exaggerate height and show that you are looking upwards.

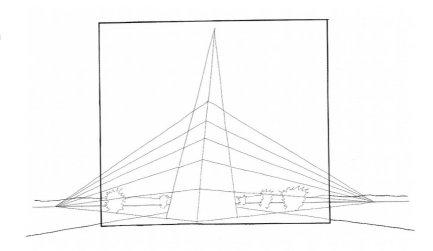

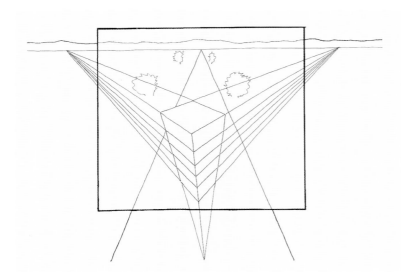

2 **If you were standing high above the cardboard tower and looking down, your vanishing point becomes submerged deep in the ground.** By drawing the sides of the boxes apparently converging to this point, you would be showing that you were looking down from a considerable height.

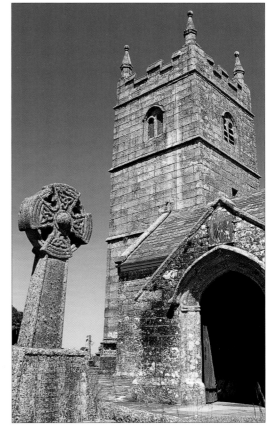

⌂ Notice how the sides of this tall building seem to converge as you look up at the tower from a low viewpoint.

Exercise 9:
Drawing an inclined plane

When you want to draw an inclined plane which has parallel sides, such as a roof, you use another vanishing point. This can be found directly above or below the one you have found for the side of the building at eye-level. (Remember that you establish the vanishing point at eye-level by turning your feet to lie parallel with the direction of the building's side.)

In order to do the following drawings you need to have plenty of space on the paper. Even just having an awareness of the position of these vanishing points will help you to draw buildings. No one is expecting complete accuracy, which is often difficult when the vanishing points are located at a considerable distance from the centre along the eye-level – often way off your paper. It is so easy to get lost when drawing and these little sketches may be helpful if you can remember how they work.

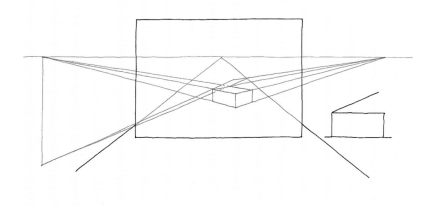

1 Tilt one of the boxes or open its lid and have a go at drawing that. Imagine the lid separately from the box, although it is attached. Its top and bottom edges are parallel to the right-hand side and can be drawn using the same vanishing point, as shown. When you open the lid a little, its other edges can be drawn using a vanishing point below the one you used for drawing that side of the box (the left and its opposite side).

2 When you open the lid more, the vanishing point for the sides of the lid is even lower, but still vertically underneath the one for the side of the box, as shown.

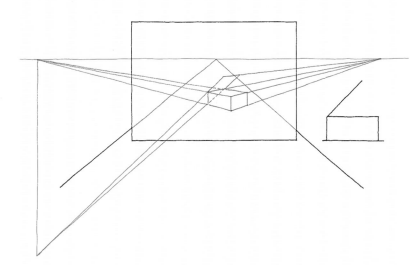

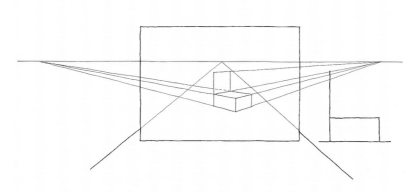

3 When the lid is open at right angles to the box itself, you don't need the third vanishing point, because it is a continuation of the side.

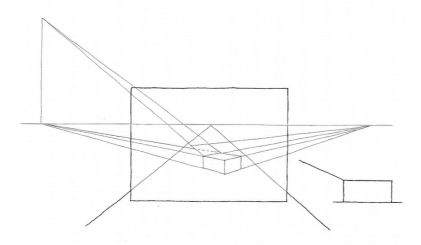

4 Once you flip the lid backwards, the new vanishing point for drawing the sides of the lid is above the one for the side of the box itself.

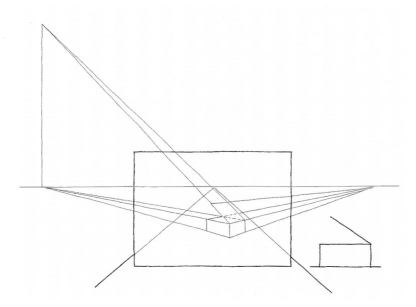

5 If you move the lid to the other side of the box, its vanishing point will be above the one for the side as in Step 4. **Now it begins to look like the roof of a miniature house, doesn't it?** The difference is that the position of your eye-level in relation to the house affects the way you see its edges.

Exercise 10: Drawing buildings

It's surprising how, when you look at the world in perspective, you find that you can break down even quite complex shapes and structures into really very simple shapes for the purposes of drawing. For example, what are buildings other than huge boxes? You have already mastered drawing boxes, so perhaps by looking at some buildings, which you might previously have thought much too difficult to draw, and imagining that they are only a series of boxes, you will be able to tackle them after all.

Looking at a cardboard box with its lid open is similar to looking at a house with a roof. The priniciples you have learnt so far can be applied to an entire group of houses, such as a village.

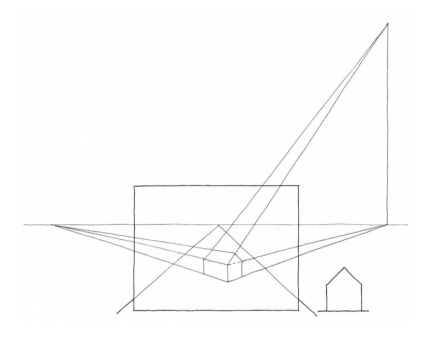

1 Here is a drawing of a box with its lid shaped like a roof. It looks like a miniature house. Although it is small and below the spectator's eye-level, locating a vanishing point for the sides of the 'roof' is done in the same way as if it were a real house as shown in Step 2.

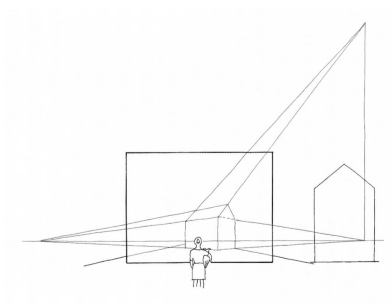

2 When the same shape is enlarged to become a real house, the eye-level affects the angles perceived on the picture plane of the top and bottom edges of the sides. The bottom edge is below the eye-level and the top is above the eye-level as shown. Finding the vanishing point for the sides of the roof is done in the same way as if it were the same size as the box.

3 Here is a group of boxes arranged to look a bit like an imaginary village street scene, with the sides of the boxes set at different angles to the viewpoint so that their vanishing points will be found in different places along the eye-level line.

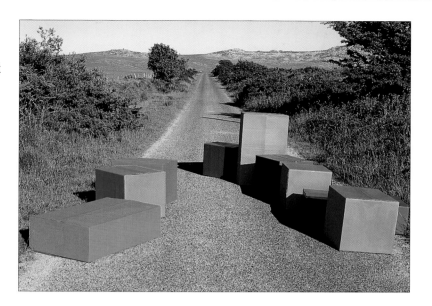

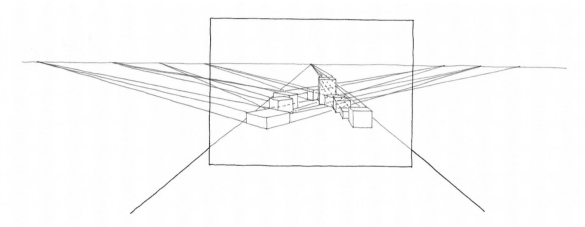

4 This shows some of the vanishing points which can be used to draw the group of boxes shown in Step 3. **Notice how closely this group of boxes resembles a series of buildings.** The different vanishing points for all the sides of the boxes can be found along the eye-level.

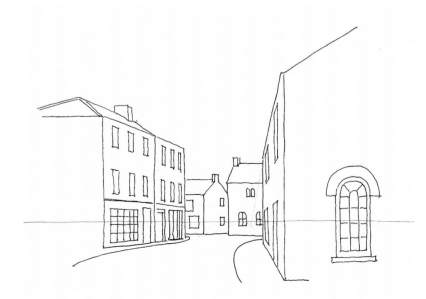

5 I did this little sketch of a village street using a line showing the eye-level and locating vanishing points along it logically which helped to make the buildings look realistic. After all the work with the cardboard boxes, it shouldn't be too difficult to apply the same idea to sketching buildings. Try guessing where the vanishing points might be.

Exercise 11: Drawing buildings below and above eye-level

The position of your viewpoint – and therefore your eye-level – in relation to a building will determine how you draw it. Remember that vanishing points for all sets of parallel horizontal lines which recede away from your viewpoint can be found on the eye-level line. You can use other vanishing points to exaggerate the impression of looking up from a low viewpoint or down from a high viewpoint at sets of vertical, parallel lines. To draw inclined planes attached to sides of buildings (or boxes) which are rectangular or square in shape, you can establish vanishing points by first finding the vanishing points for the sides of the buildings or boxes and then going vertically up or down as shown on pages 28–29.

Sloping ground

Drawing a building or an object that drops down below your eye-level because the ground is sloping away from you is not as daunting as it might first appear. Try and cast your mind back to the time you were on the beach, watching what happens when a person drops down below your eye-level (see page 12). This will help to refresh your memory.

The first thing to do is to establish your eye-level. Stand squarely, look straight ahead of you and focus on a point in the distance. Make a mental note of what is happening in that spot. Are there trees, hills or is there perhaps an architectural feature you can lock on to for reference? Draw a horizontal line and

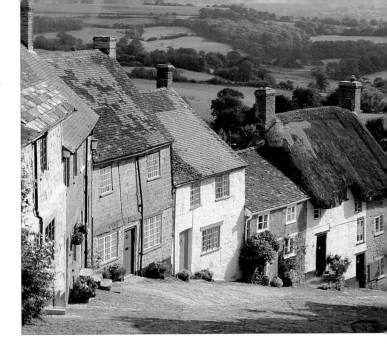

⌂ Although the ground level drops away from the viewpoint, the vanishing points for the roofs and the sides of the houses can be found as shown in Step 1 opposite. The sides and faces of the houses can be eyeballed by pointing to the eye-level as we have done with the boxes. This will help you to draw all the windows and doors correctly. The inclined planes of the roofs can be drawn using vanishing points above those for the sides, in exactly the same way as for the lid of the box (see Steps 1 and 2, page 28).

note that what happens along that line is what you were focussing on in the distance.

What gives the impression of the ground dipping away from you is the fact that you are able to look down on things – like rooftops or peoples' heads – and these may now be positioned below the eye-level line. You can measure using the vertical pencil method (see pages 24–25) so that your subjects sit in their correct location. (Refer on to Step 1 opposite.)

Looking up and down

Step 2 (opposite) and Step 3 (see page 34) show you how to draw a subject that you are either looking up to or down upon, using three-point perspective (see page 27).

1 Establish the vanishing points along the eye-level line in the same way as you did with the boxes.

To draw the parallel lines in the buildings, turn your right foot so that it is parallel with the front of each cottage, then match the angle of your foot with your arm and point to your eye-level line to locate each vanishing point (see pages 22–23). Do the same with your left foot, turning it so it is parallel with the other, largely hidden, side of the buildings.

Use what you learnt on pages 28–29 to help draw the roofs of the cottages in a more informed way.

You will see that the sides of each roof appear to converge to a point in the sky, which is directly above the vanishing point for the sides of the cottage. You can use the diagonals to establish the position of the apex of the roof as shown on page 38. You can eyeball the steepness of each roof mentally by comparing the angle of the roof with simple angles that you would

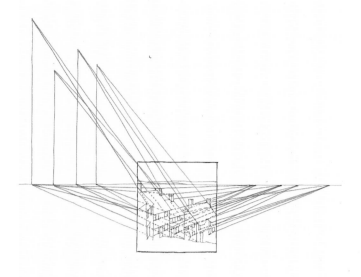

normally recognize; e.g. 45 or 90 degrees. Just ask yourself whether the angle you are looking at is greater or less than 45 degrees when compared with the horizontal eye-level line or your vertical pencil line.

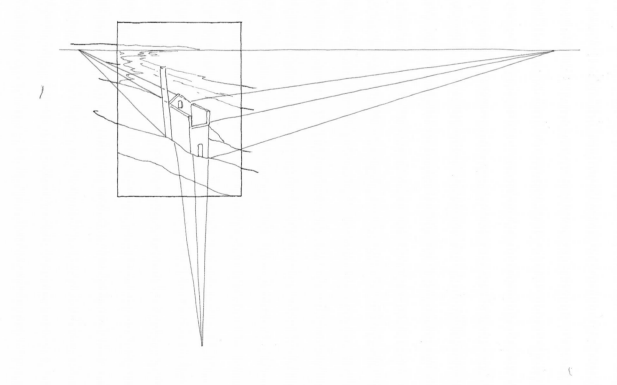

2 In this drawing the eye-level is, of course, the horizon of the sea (see pages 12–13). To exaggerate the feeling of looking down, I have introduced another vanishing point, buried underground, which helps to draw the sides of the building. This is as if the picture plane has been tipped forward (see Step 2 on page 35). You can guess the position of the 'underground' vanishing point. You don't have to be totally accurate.

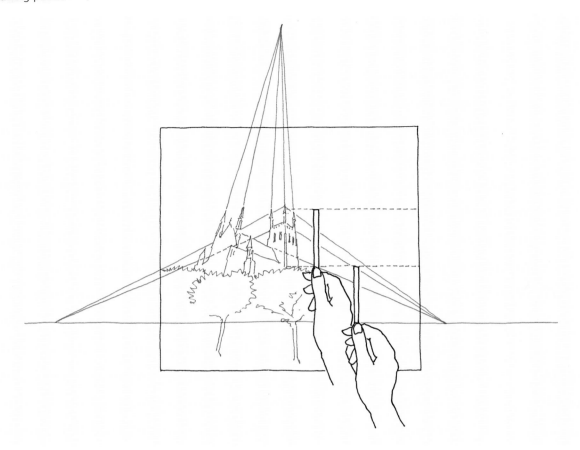

3 For looking up, say at a church on the top of a hill, pick a point way up in the sky and try to work out whether the trees are leaning towards this point.

Looking up at a tower, you will clearly see that its sides lean towards the top. Use your hands or a pencil to try and see where the vanishing point way up in the sky might be. Once you have established this point in your drawing, you will find that all of the vertical sides of the building can be drawn as if they were converging to this point, giving your work a sense of scale and grandure.

Exercise 12:
Tipping the picture plane

A helpful way to exaggerate the feeling of looking up or down on your subject is to imagine the 'glass' – i.e. the picture plane – tipped either forward or backward respectively. There's no need to be super-accurate with any of this, but an awareness of the position of vanishing points will lend realism to your work whether you are drawing or painting, and will help you to gain more confidence.

⌂ When you look up at something, not only do verticals appear to converge, but the eye-level drops, as demonstrated on the facing page.

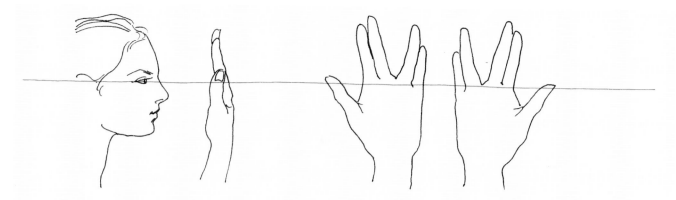

1 Hold your hands in front of your eyes with gaps between your fingers and, using your imagination, substitute the 'glass' for your hand. Try to fix your gaze on an object beyond the 'glass' at your eye-level.

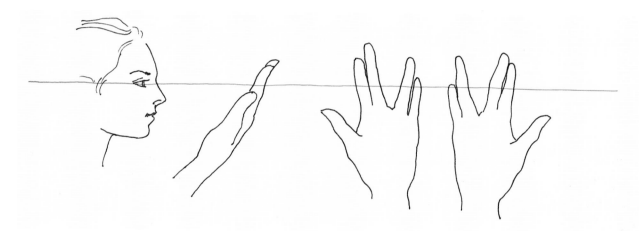

2 Tip your hands away from you and try to imagine where the eye-level would appear on the imagined glass. You will easily see that the eye-level's position on the 'glass' has risen. You can use this in your work to give the feeling of looking down on something. In short, when peering down, raise the eye-level.

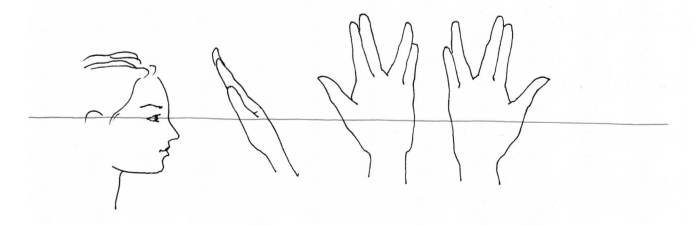

3 Conversely, when attempting to exaggerate the feeling of looking up, do the same exercise, but this time tip your hands towards you. You will notice that the eye-level drops. Use this to help your drawing.

Key

Black lines: lines as viewed in real life

Red lines: eye-level

Blue lines: drawn lines on picture plane

Green lines: important 'construction' lines

Questions and Answers

You will now have a good basic understanding of perspective, appreciating how your viewpoint and eye-level affect the way you see things. In this chapter you will find some quick and easy ways to answer other questions that you may encounter whilst drawing or painting. By following a few simple guidelines, you can learn to make your work appear much more realistic and convincing.

It is important to learn how to space things in perspective. The photograph shows an appealing street scene with buildings alongside a road. This chapter gives guidelines on how to create a painting or drawing with convincing realism so that if you find yourself out sketching on a lovely sunny afternoon, you will know how to approach such a subject.

Exercise 13: Dividing a square or rectangle in perspective

Now that you are experienced at using your eye-level to find vanishing points for parallel, horizontal sets of lines receding away from the viewpoint – the top and bottom edges of buildings, sides of roads and other simple objects – you may like to expand your expertise and try other subjects. Doing spacing in perspective is easy if you know how! Here are a few shortcuts which will help your drawing.

To find the centre of a square or rectangle in perspective use the vanishing point, then the diagonals. The area can first be halved, then quartered and so on.

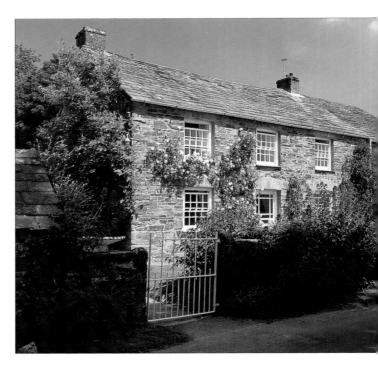

⬑ There are lots of situations whilst drawing or painting when you need to know how to do spacing in perspective – for example, when drawing this house.

1 You can use diagonal lines, from corner to corner, to find the centre of any square or rectangle, even when seen from an angle. Use a vanishing point on the eye-level to draw the top and bottom edges, then add the diagonals. This might be useful to locate the apex of a pitched roof on a gable end wall, as shown in step 4.

2 If you want more divisions, draw a vertical line through the centre and another through the centre to the vanishing point. Now you can put on the diagonals of the new smaller rectangles (or squares).

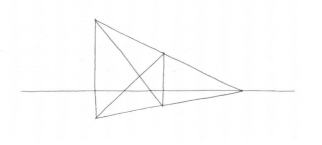

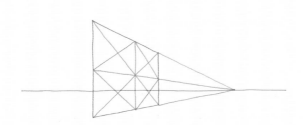

3 You can go on to halve, quarter or divide the building into as many equal sections as you want in exactly the same way.

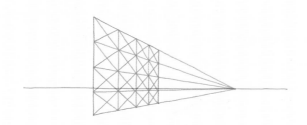

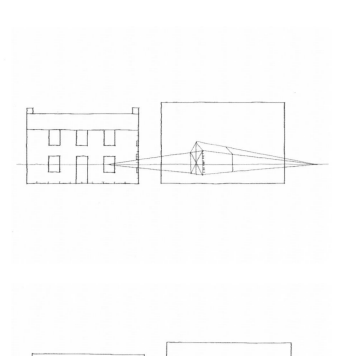

4 To draw the house shown in the photograph and show where the windows in the front wall will be in perspective, establish the position of the ridge of the roof, then divide the side of the building into the same number of sections as the face of the building - in this case, ten sections. I chose this number only because it made the positioning of the windows fairly easy. Working out where the windows are in relation to these marks on the front, I could make marks up the side of the building where the windows would occur, using the sections as a guide.

5 From these marks draw lines to the vanishing point. It's as if you have drawn the relative positions of the windows up the side instead of along the front.

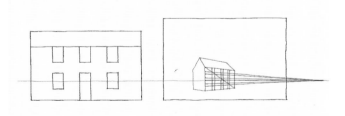

6 Now use a diagonal line from corner to corner and draw vertical lines where the diagonal intersects the lines drawn to the vanishing point. These vertical lines will show the position of the windows on the front, in perspective.

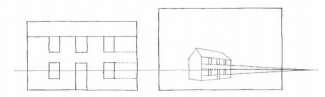

7 Now you can put in the windows with a feel for the true perspective. To recap: with a rectangle, you can divide the vertical end by the same number as the horizontal, and using a diagonal and the vanishing point for the top and bottom edges of the rectangle, you can make unequal divisions as shown. You can divide the long side in any way you find easy, as long as you do the same for the vertical side. This is really helpful when you draw buildings.

Exercise 14: Drawing rows of posts or columns

This exercise shows you how to establish the position of the next post or column in a row that is receding into the distance. This method can be used to draw any kind of row of equally spaced uprights in perspective, even battlements.

⌂ This is an example of verticals receding away from the viewpoint. Knowing a quick way to work out the spacing can make a drawing simpler to do and look much more convincing.

1 Draw the first post and eyeball the position of the second, establishing the vanishing point by placing your foot parallel to the direction in which the posts are heading. Next, draw lines along the top and bottom of the first two posts to the vanishing point.

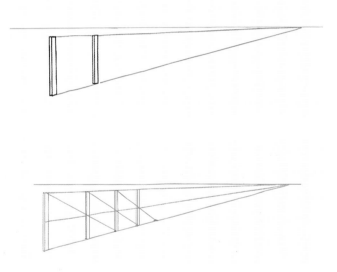

2 Draw a line through the centre of the first post to the vanishing point. Then, draw a line from the top of the first post through the centre of the second to the ground line. This point marks the position of the third post. To continue the row, carry on as described, drawing from the top of one post through the centre of the next.

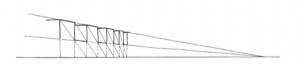

⌂ Similarly, with any vertical spacing, for example, these battlements, you can use the same system – from the top of the first, through the centre of the second... gives you the position of the third and so on. In this diagram the centre line is along the base of each cut out.

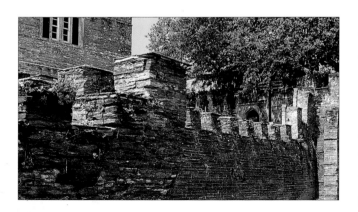

⌂ You can apply the method described above to all sorts of things, such as battlements on top of a wall. The method also works if you turn the spacing sideways to find the horizontal divisions of floor tiles, pavement slabs or a railway track.

Exercise 15: Drawing floor tiles

Another simple way to draw horizontal divisions in perspective is to remember to use the diagonal of a square. When you extend

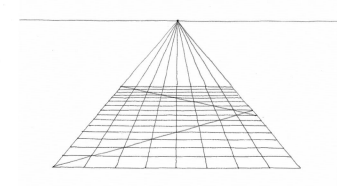

⬦ Using your eye-level, a central vanishing point and diagonal lines, you can draw this floor accurately in perspective. Eyeball the first horizontal division and draw the rest as described above.

the diagonal of the first square to cut through all the other lines on their way to the vanishing point, the divisions are marked clearly for you – in perspective – by drawing a horizontal line through each interception. This method gives you an accurate drawing.

1 Draw in your ground line and mark the positions of the full-size tiles along it. By joining the points on your ground line to a central vanishing point at eye-level, you can establish the positions of the lines which are parallel to your direction of view. In this diagram, the first horizontal line was guessed at. Draw a diagonal line through the first square on the left, and continue the line in the same direction so that it crosses through all the lines, parallel to the direction of view.

2 **In this way, you will be able to establish correct positions for all the horizontal lines.** Should the floor continue into the distance, you can draw another diagonal going in the opposite direction and complete the floor as shown.

Exercise 16: Drawing floor tiles using a simple plan

There is a slightly more complex way of drawing floor tiles, which can be better understood after having a look at pages 84–85. Using a plan and an elevation can only really be employed using scale (see page 84). You can calculate your distance from the picture plane – as this makes a difference to the shape of the tiles – and draw a simple plan.

◊ **A plan is a bird's-eye view of things:** in this case, yourself and your subject – the tiled floor.

◊ Draw a line showing the picture plane (a) and a plan above it to scale showing the floor tiles (b). Then add the viewpoint (c) (your position in relation to the picture plane). Below the plan, set out a ground line (d) and add the eye-level (e). Mark on the ground line the real size of the tiles using a suitable scale for the size of your piece of paper (see page 84). Draw lines to the central vanishing point from these marks. Draw a line (f) from the viewpoint in the bird's-eye view (c) to the back edge of the tiled area. Where this line crosses the picture plane (g), connect it vertically downwards to meet a line on its way to the vanishing point in the elevation (h). This point shows the back edge of the floor area from that viewpoint and that eye-level. Use a diagonal to position the horizontal joints in the tiles.

This may sound a little daunting, but it really isn't, just work through the exercise carefully. If you can do this then you have the beginnings of doing a perspective drawing from a plan.

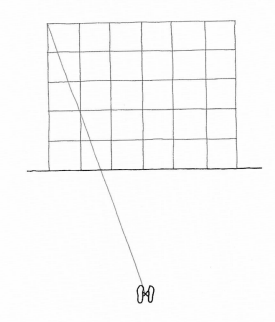

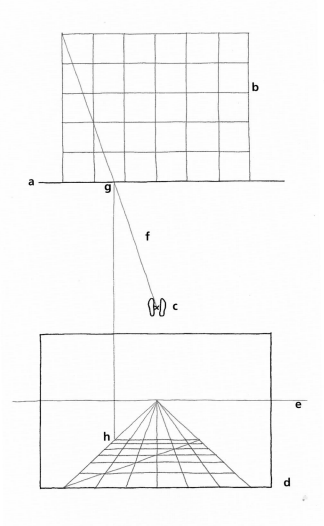

Exercise 17: Drawing circular objects

This applies to anything which needs a convincing roundness to it. The first thing to do is to have a look at what happens to an object that is circular in only one plane. This is invaluable knowledge when drawing all sorts of everyday things – urns, vases, columns, any sort of pottery – the list is long. Be aware of your eye-level before you start.

A cup and saucer

Choose a plate, saucer, cup, glass or vase (any circular object will do) and view it from different eye-levels. You will see that what happens to a circle when viewed from either below or above the eye-level is that it becomes an ellipse. The ellipse becomes 'fatter' the further it moves away from your eye-level – either up or down. When viewed at eye-level, the circle of the rim is seen as a straight line.

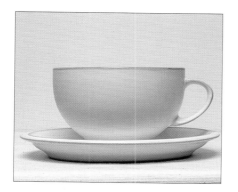

⌂ The rim of the cup at eye-level.

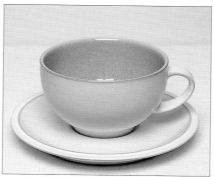

⌂ The rim of the cup below eye-level.

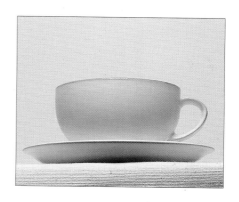

⌂ The rim of the cup above eye-level.

A bicycle

Examine it from the side (left diagram), and then from the front (right diagram). Notice what happens to the shape of the wheels and use your pencil to measure the relative width and height of the new shape (see pages 24–25).

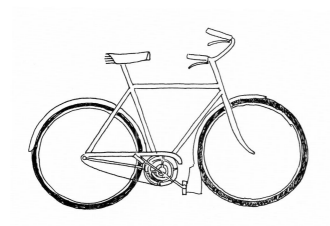

⌂ Clearly, when viewed from the side, the bicycle's wheels are round.

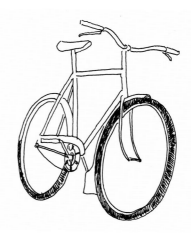

⌂ When you look at the bicycle turned at an angle to the viewpoint, the wheels become elliptical and the back wheel is smaller because it is further away.

Exercise 18: Drawing an ellipse

Depending on how accurate you want your drawing to be, there are several ways of drawing an ellipse. The main thing to be aware of is your eye-level, as it affects the breadth of the ellipse, as shown in the photographs of the cups on page 43.

Eye-balling a circular object

A useful way of drawing an ellipse quickly is to use your pencil to measure the depth of the ellipse as you see it on the picture plane. In other words, your vertical view of it compared to its apparent width – your horizontal view. In technical terms, these would be called the minor and major axes of the ellipse and I will explain more about these later on (see page 47).

Often when drawing and painting, people like to imagine that they have more of a bird's-eye view of an ellipse than they actually do, which gives a rather naïve or childlike impression. If you want your work to have a realistic feel, take great care studying the shape of the ellipses shown right when you intend to describe a circle in perspective. Particularly, notice the curved shape at either side of the ellipse in the top diagram.

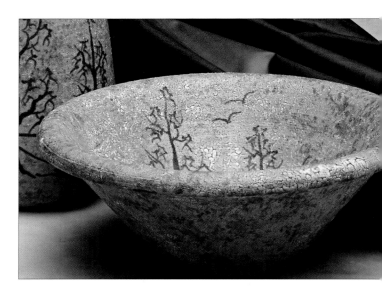

⌂ The rim of this circular bowl, when seen from this particular viewpoint, forms an ellipse which is almost three times wider than it is deep. Use the method of measuring with your pencil to observe this (see pages 24–25). Note the curves at the sides of the ellipse.

⌂ **This diagram shows the true elliptical shape of a circle in perspective...**

⌂ ...and this drawing shows the commonly perceived, but incorrect shape.

A more accurate method

This method of drawing gives you a more accurate ellipse than you can achieve just by eyeballing a subject.

1 Draw a horizontal square in perspective as accurately as you can with the central vanishing point at eye-level, as usual. Be careful not to make the square look too fat. By adding diagonals you will find its centre. Draw two more lines: one horizontally through the centre and one vertically through the centre to the vanishing point.

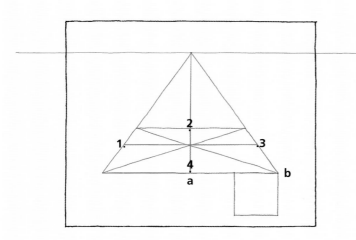

2 Points 1–4 show four points of the circumference of the circle. Now draw a small square as shown, where the sides are half the distance from (a) to (b).

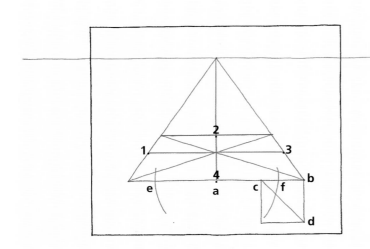

3 To find further points, mark the diagonal of the new square (c–d) and use the length of the diagonal as the radius of a circle centred on (a). Using a compass, mark the points where this circle cuts the bottom edge of the square at (e) and (f).

(Sequence continues on page 46.)

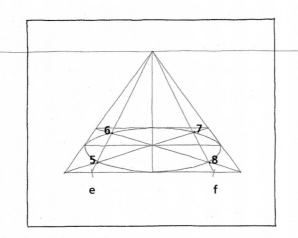

4 Connect (e) and (f) to the central vanishing point. You can now draw an accurate ellipse within your original square, using the points where these lines intersect the diagonals (points 5–8) as extra guidance when completing the ellipse.

◊ Using a vanishing point on your eye-level and turning this method (see page 45) sideways, will enable you to draw this waterwheel with some degree of confidence. Before starting the drawing, the first thing to assess is your eye-level.

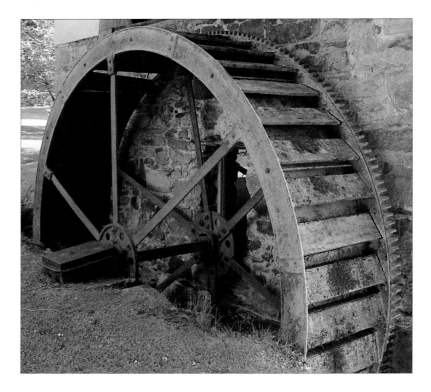

◊ To draw the waterwheel I drew two ellipses side by side – making a sort of sandwich. I used the above method to draw them, containing both sides of the wheel within two boxes whose upper and lower edges appear to converge to a vanishing point on the eye-level.

Drawing an accurate ellipse

This last method of drawing ellipses is particularly useful when you want to do a large, accurate ellipse. It's not much good on a small scale because it is so fiddly. All you really need is a tape measure or ruler, some string, a pencil or a piece of chalk and something to stick the string to the drawing surface with – masking tape or blu-tack. In addition, another pair of hands, a chalk line and a large blackboard compass make the job a lot easier.

1 Using a large blackboard compass or a piece of string with a pencil attached to one end, draw a circle centred on the top of the minor axis (a–b), whose radius is half the major axis (c–d; x marks halfway point). You don't need the whole circle – just cut the major axis on both sides as shown. The two points (e and f) where the circle cuts the major axis are two 'centres' that you need for drawing the ellipse.

2 Now attach a long piece of string to both 'centres' (e and f) firmly. This is where the help of another person is invaluable, but if you are on your own use tape or blu-tack. The string should be long enough, when pulled tight, to reach the top of the minor axis (a), whilst held firmly at both 'centres' (e and f). Carefully hold a pencil or chalk so that it rests inside the tightly pulled string. Now, keeping the tension consistently pulled outwards as you drag the pencil around inside the string, follow the shape that the string allows the pencil to make on the surface. If all is done carefully, your pencil will describe a beautiful ellipse which touches the ends of both axes. The longer the major axis is in relation to the minor axis, the thinner the ellipse will be.

A line drawn the full width of the planned ellipse from its outer extremities – in other words, its longer axis – forms a horizontal line (it could be vertical if the ellipse was longer in height than in width). This is called its major axis. The depth of this ellipse is shorter and is called the minor axis. Both lines bisect the shape; therefore the shape of the ellipse is the same either side of the axes. This method of drawing ellipses always works providing that you have already established the length of both the major and minor axes.

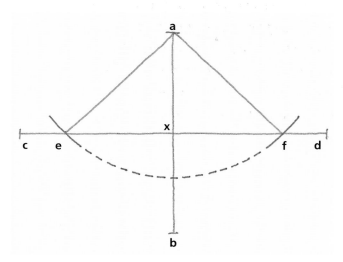

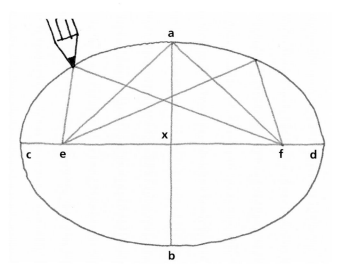

Exercise 19: Drawing columns

If you want to draw columns, here are a few hints. If you try to draw the square base of a column, having already drawn the column itself, you will run into difficulties. It's easier to draw the square base first, using vanishing points on the eye-level for the parallel edges of the base as we have done before with the boxes, and then sit the column inside its base, starting with an ellipse (see pages 44–47).

1 Using a vanishing point on the eye-level, it helps to imagine a column as being square. Look at Step 4 to see how to fit the elliptical top and bottom of the column into its base.

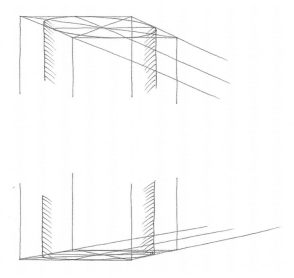

2 Use diagonals to divide the square. (You can use the method described on page 45.) A circle touches the middle of each of the four sides and is much easier to position and draw like this. It gives the top and bottom of columns a more convincing shape. Joining the outer extremities of the ellipses vertically, from the bottom to the top, constructs the column.

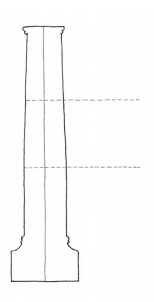

3 When drawing a column, try to remember that columns are wider at the bottom than the top. I usually measure outwards from the centre in order to make this accurate, which is why it's important to know where the centre is. Usually columns are the same thickness up to about a third of the way up, then they diminish towards the top.

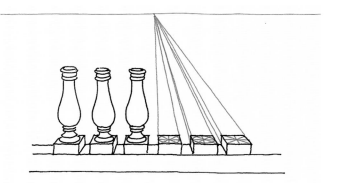

4 You can also apply the same principles to draw the bottle shapes of a balustrade. If they are in a line like this, you can trace/copy the shape since they are all the same.

Exercise 20:
Drawing windows and doors

Drawing windows and doors from different angles can seem daunting, but try to remember that you can guess where vanishing points are in the same way as before, by using your feet to guide you in the right direction.

Windows and doors which are shut are easier than open ones, especially when looked at straight on, as you may only need to consider one central vanishing point. However, quite often a window is set in a recess in the wall which may have sides that are slightly flared and will not, therefore, be parallel to the direction of your view. In order to draw the top and bottom edges of the window recess, angle each foot in turn so that it lines up with the side of the opening that you are looking at and points in the same direction to the eye-level to locate a vanishing point, which will enable you to draw the necessary edges correctly.

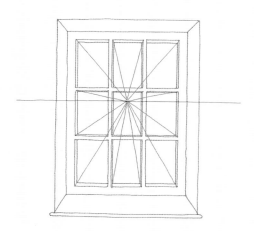

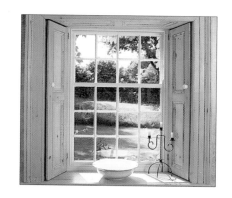

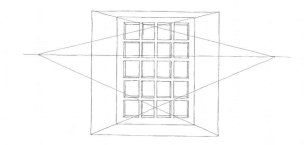

1 This is a simple shut window set in a recess, where the sides of the recess are at right angles to the window itself. **Even though this window is closed and apparently has no perspective, you can make your drawing much more realistic by putting in your eye-level and establishing a central vanishing point.** The edges of the recess form lines that are parallel to the direction of view, as do the edges of the window panes, and they can all be drawn using the central vanishing point. This means that, as the eye-level is nearer the top of the window than the bottom, the windowsill appears deeper than the top or sides.

2 This window is set into a recess where the sides are not at right angles to the window itself, but are slightly flared instead (see photo above). To draw the top and bottom edges of the recess, use your feet to establish the position of the vanishing point at eye-level (see page 23). Notice that the two vanishing points for the edges of the recess lie either side of the window itself. You can then use the central vanishing point to draw in the edges of the window panes. If your viewpoint is central the window will be symmetrical vertically – so one side will be a mirror image of the other.

Drawing an open window or door

When you open a window, its top and bottom edges and any horizontal glazing bars form lines which are no longer parallel to the direction of your view. The position of the vanishing point along the eye-level depends on how much you open the window. When the window is open at right angles to the wall in which it is set, these horizontal lines are parallel to the direction of your view, so a central vanishing point is used. Closing it a little means moving the vanishing point slightly away from the centre – in this case, to the left. The more you close the window, the further along the eye-level the vanishing point moves.

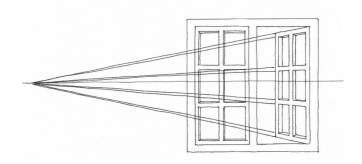

1 Start with the window open at right angles to the wall in which it is set. Now the top and bottom edges and glazing bars are parallel to the direction of view and so appear to converge to a central vanishing point. As you close the window gradually, you move its vanishing point along the eye-level, in this case to the left. You can locate this point using your foot and arm as shown on pages 22–23.

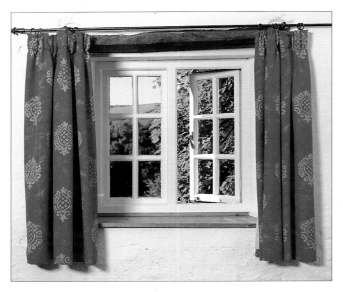

⇪ ↻ You can almost feel the fresh air and sunshine in these photos. There is something very inviting about an open window or a pair of French windows leading out to a lovely, sunny garden. Knowing how to draw them can make them ideal subjects for a painting.

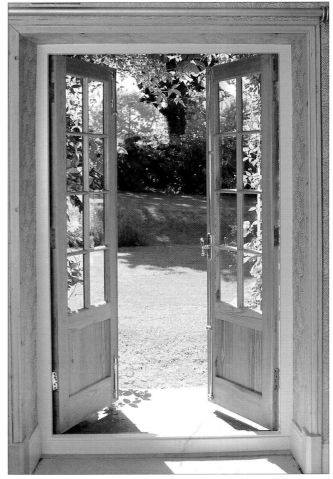

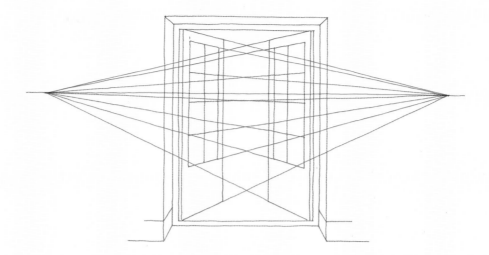

2 You will also notice when drawing an open door that the vanishing points are found to the sides. The vanishing point moves closer to the centre as the window or door is opened wider. As with the window, when the doors are opened at right angles to the wall in which they are set, their horizontal edges and glazing bars are parallel to the direction of your view and can be drawn using the central vanishing point.

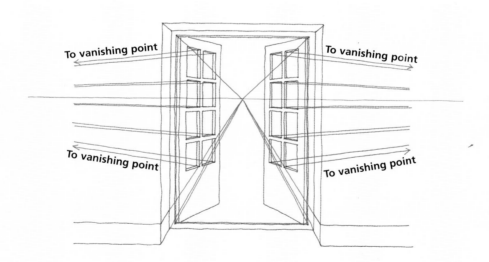

3 You will see that my sketch for Step 2 looks a bit flat. This is because I have not shown the thickness of the doors. This can be done by finding the vanishing points of these edges just as you did for the cardboard box on pages 22–23. Although one side of the window or door is much less visible than the other, drawing it in will make your sketch more realistic. The vanishing point for these edges will appear on the opposite side of the window or door to the vanishing point for the wider edges and may be a long way along the eye-level out to the side of the door opening.

These two new vanishing points for the corners of the panes of glass can be used to make the door look more three-dimensional and realistic. These vanishing points may be way off the paper, but you can still locate them on a flat surface or estimate their position. This diagram shows how these other vanishing points work. The central vanishing point helps to draw the corners of the opening in the wall and of the door frame as these form short lengths of lines which are parallel to the direction of view. This exercise can be done using a plan, see pages 84–85 and 90–91.

Exercise 21: Drawing arches

Arches are an appealing subject and have presented an artistic challenge throughout history. I think the reason for the appeal of an arch is simply that the architectural alternative is an opening with a square top. Human beings have always tried to enhance their surroundings, so that elevating the top of the opening into a naturally more beautiful and extravagant shape is an interesting alternative. As artists, we have followed our architects with representational images, which themselves have more charisma because the shapes depicted are more alluring.

Let's start with the simplest concept of looking at an arch straight on. As your confidence grows you can move on to more complex exercises.

The first thing to note about an arch is that the shape of it is affected by the eye-level of the observer. Although the thickness (depth) of the arch remains constant if observed in section (cut through), the apparent depth of the curve at the top is affected by the height of the eye-level when seen from a viewpoint in front or behind and it is this shape we would like to describe correctly on the picture plane.

Drawing an arch from a central position

When you draw an arch looking straight into it from a central position between its sides, start by working out where the eye-level should be relative to its height – taking the eye-level at 1.5m (5ft) above the ground and estimating or measuring the height. Then draw the shape which is nearest to you – the shape the arch makes in the outer face of the wall.

⌂ This arch in the Grand Hall at the Old Bailey (London's Central Criminal Court) shows clearly that you can see more of the underside of the top of the arch because the position of your eye-level is relatively low.

⌂ When your eye-level, relative to the height of the arch is near the top, the apparent depth of the curve is less than the sides, as you can see in this example.

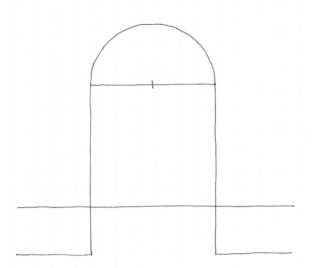

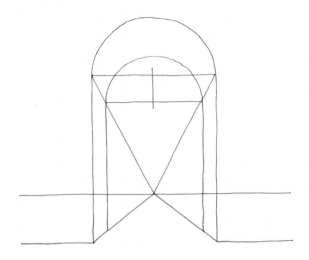

☐ In the case of an arch with a semi-circular top, the centre of the curve will be in the centre of the opening and will sit on a line drawn between the points on either side from which the arch springs.

☐ The point from which the arch begins its curve and an identical point on the 'back edge' of the arch (the opening as it appears on the far side of the wall in which it is set) theoretically form a straight line parallel to the direction of your view. Using a central vanishing point on the eye-level you can draw this and also the bottom 'inner' edges of the opening. Using a compass, draw a smaller semi-circle which fits as shown.

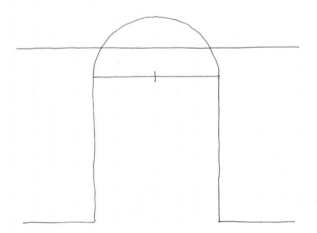

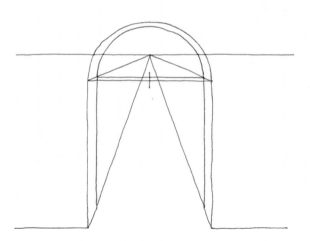

☐ When drawing a low arch, you can use the same method as shown in the two diagrams above.

☐ You will discover the apparent depth of the arch at the top is narrower than the sides, whereas with a high arch, when your eye-level is relatively low, the top appears much deeper.

Drawing a non-circular arch from a central viewpoint

When the arch is not circular, but some other shape, like the example in the photograph right, it helps to imagine that the top is square as shown by the dotted lines.

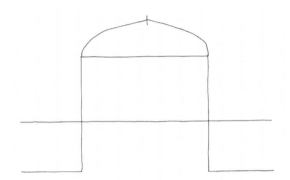

1 Firstly, draw everything as it appears on the nearer surface – i.e. the front face of the wall, exactly as you did with the semi-circular arch (see pages 52–53). Make a horizontal line from where the arch begins to the same point on the other side of the opening and put in the eye-level as usual. In this case, it's quite low compared with the height of the arch.

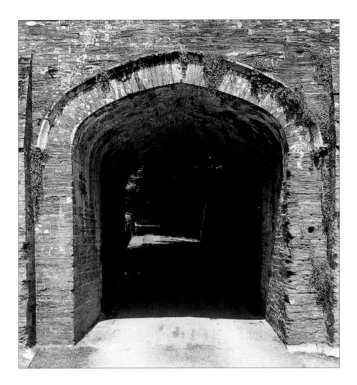

⌂ Even though this arch has a Gothic shape, it still looks wider and deeper at the top because the eye-level is relatively low.

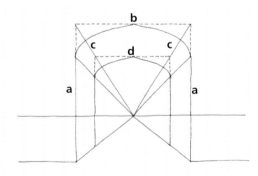

2 Using a vanishing point in the centre on the eye-level, draw the bottom inner edges of the opening – lines which are parallel to the direction of your view. Extend a vertical line which forms the 'nearest' corner of the opening (a) upwards to meet at right angles a horizontal line extended from the centre where the arch is at its full height (b). Now you have a 'corner'.

From this imaginary corner draw a line to the central vanishing point crossing the vertical 'back edge' – also extended upwards (c). (Eyeball the position of the vertical back edge of the opening, depending on the thickness of the wall.) From the point of intersection of these two lines you can draw horizontally back towards the centre which will give you the full height of the furthest peak of the arch (d). You can find the points from which the arch that is furthest away springs exactly as you did with the semi-circular arch – knowing that both the nearer and the further away points lie on a line which is parallel to the direction of view, so both will be found on a line drawn to the central vanishing point from the nearer face. With an arch like this you only need to draw one side perfectly as the other side will always be a mirror image and can be 'flipped over' with tracing paper.

Drawing an elliptical arch

This is an example of a low, elliptical arch, usually found in rooms where the ceiling height doesn't allow for a full semi-circle.

1 As before, draw the things you already know as they appear on the nearer face of the wall. A description of how to draw ellipses is shown on pages 44–47. For an elliptical arch I usually use the method shown on page 47. A horizontal line drawn between the two points from which the arch springs forms the major axis and a vertical line from the centre of the major axis to the top of the arch forms half the minor axis. (We only need the top half of the ellipse for drawing this arch.)

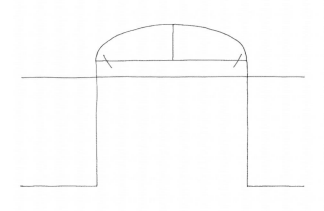

2 Now follow Steps 1 and 2 on page 47 to draw the ellipse, using two centres which you have found by drawing a circle with a radius that is half the length of the major axis – i.e. half the distance from side to side between the points from which the arch springs.

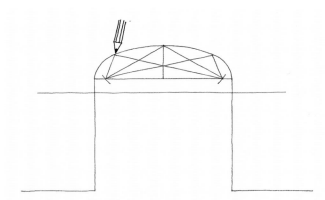

3 Make an imaginary corner in exactly the same way as for the non-circular arch opposite, in order to discover the full height of the arch as it appears on the far side of the wall, and use the central vanishing point to find where the arch begins on the far side of the wall as you did before. Now you have enough information to draw a second ellipse correctly, as you now know the length of both major and minor axes in perspective.

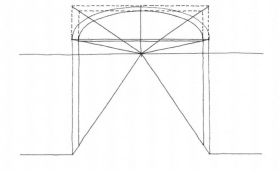

Observing clouds

It is wrong to assume that just because clouds are soft and fluffy and do not have rigid shapes that they have no perspective. Tremendous depth can be added to your paintings by appreciating how clouds are perceived on the picture plane. By describing their shape and colour well, one can exaggerate distance.

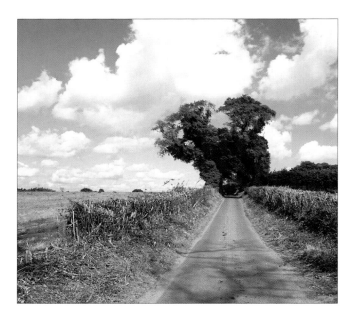

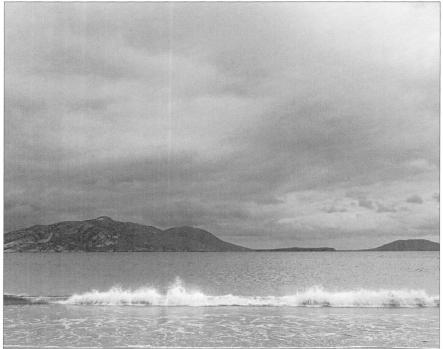

⌂ In this photograph, the cloud shapes are quite separate and distinct. Those close to the horizon are much smaller, both in width and height. In fact, if you look carefully, you can see that the clouds just above the horizon are tiny! They grow much bigger as they come towards the viewpoint.

◊ In this seascape, although the clouds are softer and are merged together, you can still see that they form horizontal lines which become closer the nearer they are to the horizon.

◊ The perspective in this photograph is exaggerated by the fact that the clouds are mirrored in the water. When this happens, the distant small clouds are near the horizon, both in the real sky and in the reflection, increasing in size towards the top and the bottom. This photograph leads neatly on to the next subject area – how to look at and draw reflections.

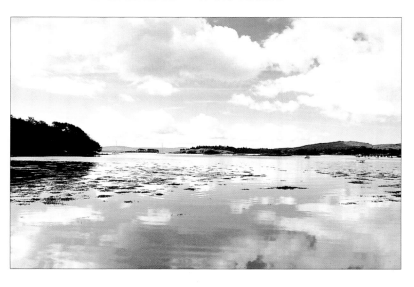

Representing reflections

When drawing and painting you will come across many situations where having drawn your subject well, you have to represent its reflection. I'm going to concentrate on how to represent a reflection in water.

Water acts like a mirror. To help you to understand how reflections work, get a household mirror and, with the reflective side upwards, lay it horizontally in front of different objects around the house. Try looking at the mirror and the object from different eye-levels and examine how it changes what you can see. The higher your eye-level, the more you see the reflection as if you were looking up at it – but upside down. As you lower your eye-level to the surface, the way in which you see the reflection is more of an exact replica of the subject.

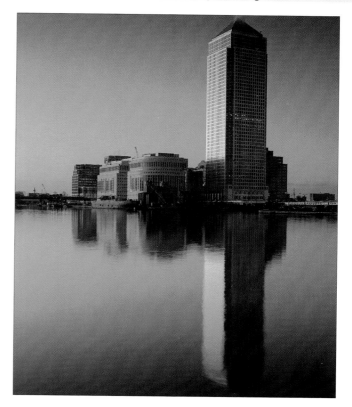

⌂ Your eye-level in relation to the subject affects both the real thing and its reflection. This skyscraper was photographed from near the water's edge and the edges of both the real buildings and their reflections can be drawn sharing the same vanishing points on the eye-level, as with the posts on page 58.

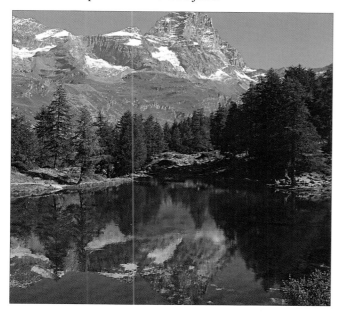

⌂ In this photograph, we see more of the mountain above the water line than of its reflection below, because the eye-level of the photographer was so much higher. In order to exactly mirror the mountain with its reflection, the photograph would have to be folded along a much higher line or eye-level.

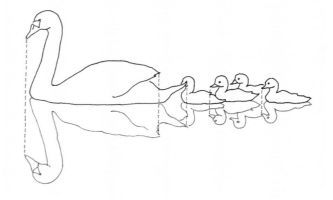

⌂ **Dropping a vertical line from key points on the subject into the water will help to guide you when you draw a reflection.**

Exercise 22: Reflections and the viewpoint

These diagrams show how reflections of simple objects vary depending on whether they are upright or leaning away from or towards the viewpoint.

When water is disturbed or rough, it's as though a mirror has been rippled and the surface, although remaining reflective, has become thousands of small areas of glass. What you need to do is try to understand how the surface is picking up and reflecting different objects and how you are seeing them on the picture plane.

⌂ The faces of the box and the post are reflected exactly, upside down in the water. The side of the box is drawn using a vanishing point on the horizon in the usual manner and the reflected side can be drawn using the same vanishing point as shown.

⌂ The post leaning to one side is parallel to the picture plane. In other words, it is leaning neither towards or away from the viewpoint. Like the post in the diagram shown left, the reflection is exactly the same upside down.

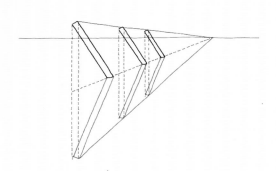

⌂ The top of a row of posts leaning towards the viewpoint form a line which can be drawn using a vanishing point at eye-level, in this case on the horizon, and the tops of their reflections (or rather their bottoms) will form a line receding to the same vanishing point. Notice that when the post is leaning towards the viewpoint, the reflection is longer than the post itself.

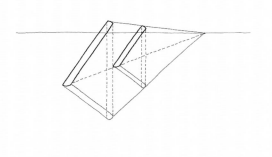

⌂ Conversely, when the posts are leaning away from the viewpoint, the reflection is shorter than the post itself. The top of the post and its reflection can always be connected vertically.

This page shows some examples of different reflections. Careful observation and thought using the simple ideas mentioned on pages 57–58 will help you to understand how reflections work. Now you should be able to draw or paint water which looks wet.

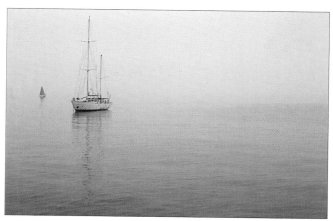

⌂ **When the surface of water is disturbed, verticals are sometimes extended downwards because the individual face of every wave becomes a mirror and picks up part of the image.**

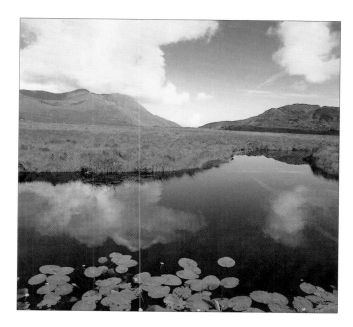

⌂ **A reflection in calm water is simply a mirror image.** You can learn how the upside-down image works by laying a mirror flat on the floor.

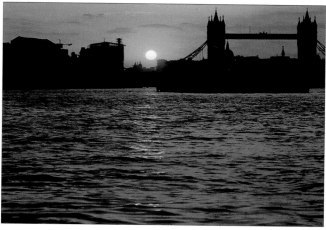

⌂ Fragments of sunlight form a vertical broken path, when the water is disturbed, the pieces becoming smaller in the distance.

◊ In this image, the eye-level is slightly above the water level (just above the lowest window). Both the castle and its reflection have vanishing points along the eye-level which would be useful to know if you were going to draw this scene.

Painting the sea

Really rough water is difficult to paint and you are unlikely to feel like painting it if you are on it! However, if you have the constitution of an ox and nerves of steel (not to mention good waterproofs), it can be the most exhilarating subject of all. Seen from the air, waves make a remarkably regular pattern; curved lines radiating from vanishing points on the horizon. Near the horizon they flatten out, almost matching the curve of the earth's surface and the pattern becomes indistinct with the lines too close together to see. Waves are caused by weather conditions, tides and, in some cases, ground disturbances. Whatever the weather conditions, you will still see a pattern and should be able to use the basic principle as shown in the aerial view to give your work distance and perspective.

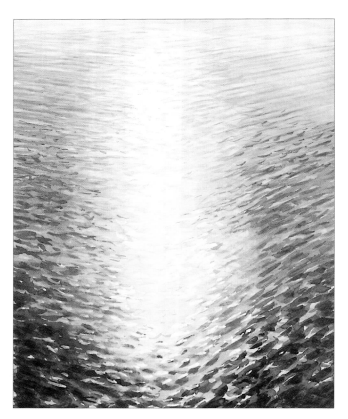

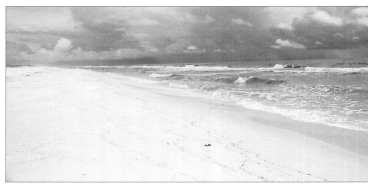

◊ Seen from the air, waves make a regular pattern on the earth's surface – they are parallel to each other, but appear to converge somewhere on the eye-level as usual. They are seen to radiate outwards in curved lines from the horizon.

◊ Coming down to earth but still looking at the sea from a high viewpoint, you can appreciate the pattern of lines radiating from a vanishing point on the horizon – which will always be your eye-level – becoming closer together in the distance as in the aerial view and use it to provide perspective in your drawing and painting.

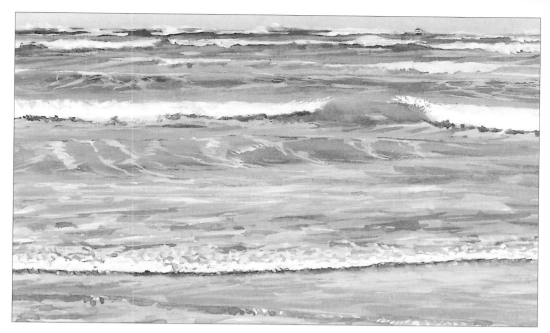

◊ **Distance is created by the difference between how small the waves you can see near the horizon are, compared with the space occupied by the waves in the foreground.**

◊ Painting waves has always been a popular subject. When you are close to the sea, the breaking waves appear right up to the horizon. Using a vanishing point on the horizon will guide you towards getting the perspective of the sand and sea right, as they are made up of lines which are parallel to each other but not parallel to the direction of view.

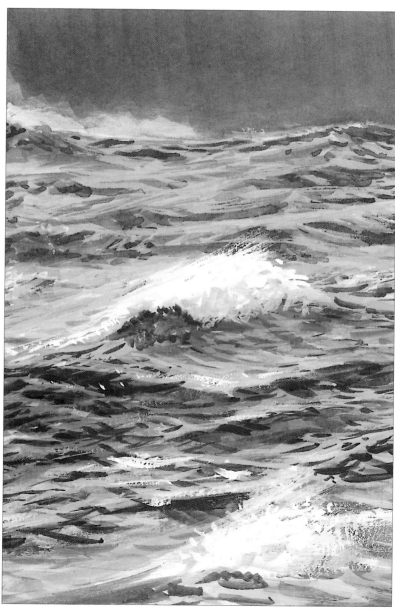

◊ Very difficult to paint from life in these conditions! If you want to recreate the drama in the studio – remember to make the waves smaller in the distance.

Exercise 23: Drawing shadows

Shadows are best imagined as areas left untouched by the sun's rays. These rays of light travel in straight lines, bypassing the subject in question and leaving an almost unrecognizable shape shaded from the sun.

To get to grips with the basics, let's go back to the long straight road and our trusty cardboard box. This series of diagrams is very simple: it shows how the shadow is cast and how the position of the sun's rays affect the shape. Shadows also have vanishing points and these vanishing points can be found in exactly the same way as the vanishing points for the object itself – by turning your foot parallel to the edge of the shadow, lining up your arm with your foot and pointing to your eye-level. You can then draw in the vanishing point.

1 The sides of the box and its shadow are both sets of parallel lines, but because the direction of the sunlight is different from the angle of the box, they do not share the same vanishing point. However, the 'top' edges of the shadow share the same vanishing points as the top edges of the box making the shadow.

2 This diagram shows simply how the shadow of the box works when the rays of sun are parallel to the picture plane, in other words, if the sun is shining from the side.

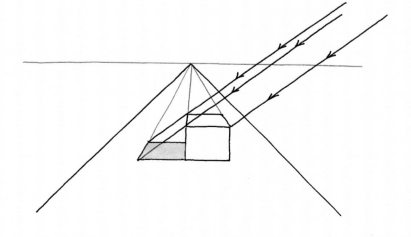

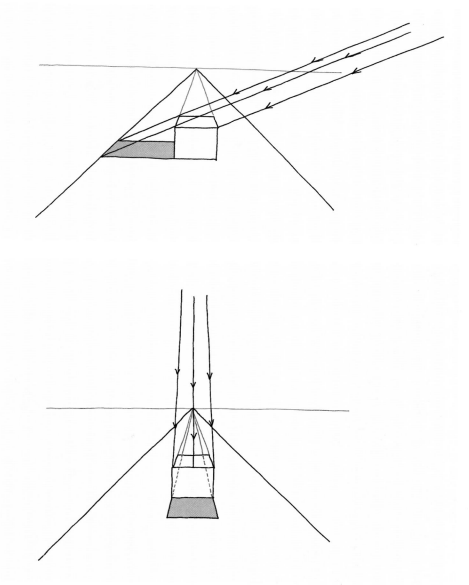

3 As the sun sinks lower in the sky (or has just started to rise) the shadow made by the object is longer. The edges of the shadow can be drawn using the same vanishing point as the box itself.

4 When the sunlight is on the far side of a box whose edges are parallel to the direction of view and parallel to the picture plane, the sides of the shadow can still be drawn using a vanishing point at eye-level.

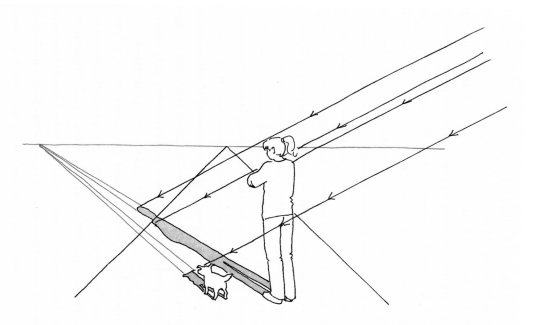

5 Even when the subject doesn't have a regular shape, it still helps to notice that the shadows appear to converge towards a vanishing point on the eye-level.

Shadow shapes and colour

I really do not believe that one needs very complicated explanations of the geometry of shadows. What you do need when you are painting or drawing is an acute awareness of the position of the sun or main light source, so that you can utilise it to create realism in your work. Using shadows helps to create depth and distance in your painting and, if they are positioned well and used in combination with the elements that we have discussed, you will be amazed how much more convincing your work will become.

It's all very well to learn how to draw the shape of the shadow but one of the most important aspects of all is to learn how to make the shadow the right colour. A shadow is the place obscured from the sun by the position of an object, the fact is that the lack of sunlight itself can be shown on the picture plane as a colour which is completely different from the place in full sunshine. For tips on identifying the colour, see pages 70–71.

⌂ Practise looking at shadows by setting up a series of still-lifes so that you learn by observation. You can move the light source to different angles to experiment with what happens to the shape of the shadows.

◊ This photo of a leafy lane shows how interesting the interaction of light and shade can be.

⌂ At times you may be faced with a shadow that makes an awkward shape and doesn't seem true to life. Create a more realistic version. No-one will know if it is accurate.

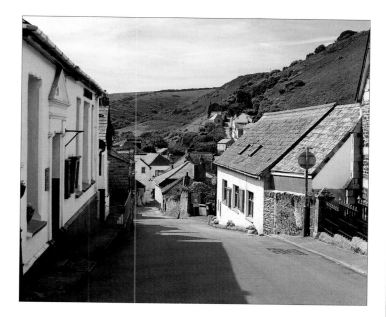

⌂ ◊ At first glance the shadows in these street scenes seem very complicated. Keep calm, be aware of where the sun is and compose your drawing in a considered way. No one will question what you have drawn because they won't have seen the original, but you do need to be aware of the perspective of the shadows, so try to use the knowledge that you have in a sensible way. For example; in the picture above, the top of the shadow of the roof shares the same vanishing point as the top and bottom of the house's walls.

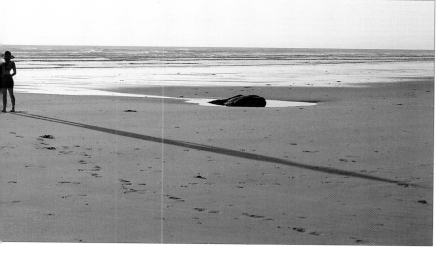

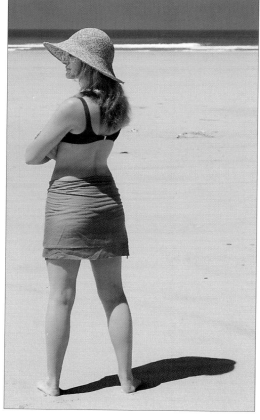

⌂ ◊ These two photographs of a figure on the beach were taken at different times of the day and clearly illustrate how the length of the shadow is affected by the height of the sun in the sky. **Always be aware of the sun's position, as it creates a certain atmosphere and gives the viewer a feel for the time of day.**

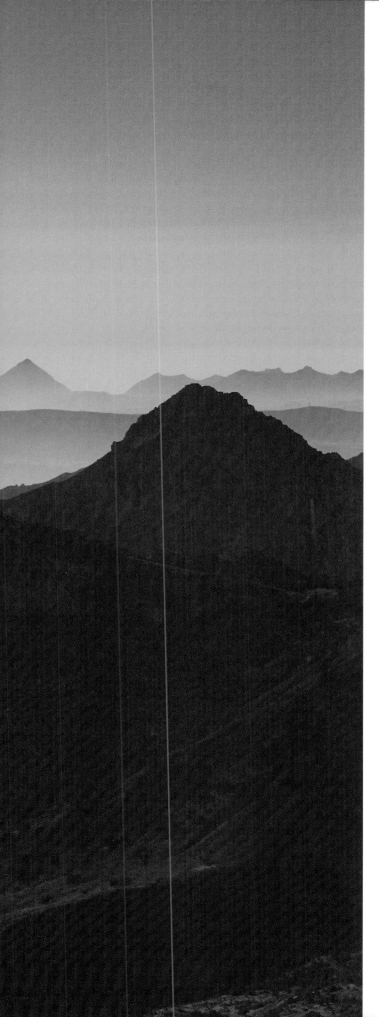

Aerial Perspective

For landscape painters an understanding of aerial (also known as 'atmospheric') perspective is invaluable. A feeling of distance is created by the variation of colour between the foreground and whatever features there are on the horizon. Try to imagine that you are 'in' the sky and that your view of the landscape is becoming increasingly obscured by the density of the sky as more of it comes between the viewpoint and the subject further away.

This photograph shows clearly how sky diffuses our view of a landscape as it recedes from our viewpoint. We naturally understand how colour describes distance because our eyes automatically do the work for us, but when it comes to painting, you may need help in order to work out what you are really seeing.

Exercise 24: Achieving realism in painting

People misunderstand the idea of aerial perspective, thinking that as objects recede into the distance, away from their viewpoint, they simply become fainter. Merely adding a splash of white paint to the colour of your subject doesn't make the object look further away. It needs a lot more thought than that!

Realism is achieved in painting by using good perspective drawing in conjunction with realistic colours – colours as they actually appear on the picture plane. You need to analyze your perception of your subject's colour through the imaginary glass.

When you are looking at a landscape, try to imagine that you are 'in' the sky. Sky is not something that just rises above the horizon in the distance. It drops like a gauze in front of our eyes and as our view becomes more distant, more layers of gauze diffuse our sight.

Painting sky and hills

When painting scenic backdrops for the film industry, I used a technique using a spray paint gun (see Steps 1–4 opposite) which can be adapted for painting on a smaller scale in any medium. The drawings opposite show the principle of aerial perspective in landscape painting. You can do the same thing on a small scale using paint flicked on to the surface with an old toothbrush or applied in thin washes of colour diluted with water if using water-based paint or suitable medium, if using oil paints.

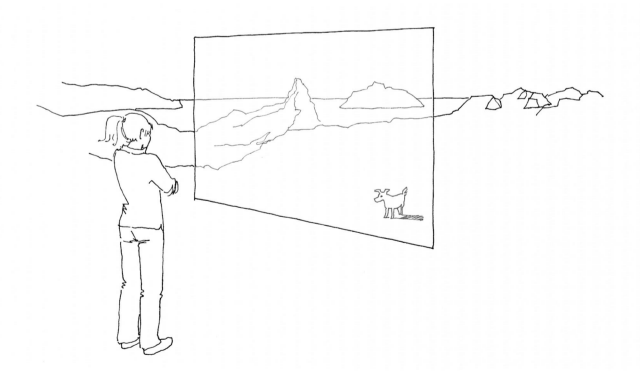

⌂ Stand and look at a landscape and imagine the glass picture plane in front of you. Think about the colours you are actually seeing. It might be helpful to imagine yourself putting a blob of paint on to the surface of the glass itself. **If your blob of paint were to disappear into your subject (as seen through the glass), then clearly you would have mixed a colour which was true to your subject.**

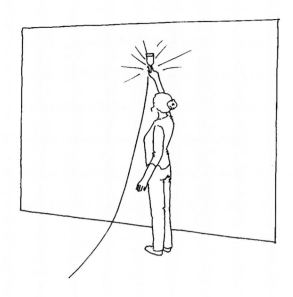

1 Using a spray gun and an air compressor I applied sky colours over the whole area, working from the top downwards. I used reference – photographs and a colour index – to check against the sky (see page 71).

2 I established a line of hills and mountains, painted in solid colour, right down to the bottom. Again, I used reference to find a suitable colour. I sprayed over the first line of hills using the lowest sky colour – the one nearest the horizon.

3 Next I painted a second line of hills, leaving the first line visible above the second. I sprayed again, using the same colour. The first hills became even more diffused.

4 After the third range of hills, I'd achieved something similar to the photo on page 66. You can paint as many ranges of hills as you want. In the end, the first set will be barely decipherable from the sky itself.

Exercise 25: Perceiving colour on the picture plane

Head off to a landscape that you like or one that you're interested in drawing or painting. Take a paint manufacturer's colour index with you, showing, if possible, hundreds of different colours in infinitesimally small changes of shade and either a pencil or some small stickers.

Look at the landscape and imagine the glass picture plane in front of you. Make sure that the colour cards are well lit by daylight, tilted in such a way as to catch light from above. You should be able to decipher changes in the colours of the sea, rocks, foliage, sky and any other features observed in front of you.

By flicking through the colours you will soon get the hang of spotting the exact colour of your subject as it appears to you on the picture plane. Notes written in pencil on the index will be useful if you are returning to the studio to do the painting.

Using colour to describe distance

Aerial perspective will describe itself by the changes in colour that you perceive and you will soon learn that hills don't just get lighter in the distance. You will discover that although a distant hillside is covered with grass – the same colour as the grass on which you are standing – its colour has been altered by the intervention of atmosphere, it has been affected by aerial perspective. Usually you may need to add not just white, but perhaps other colours such as cobalt blue and magenta. Quite often I find that adding some of my sky colour to the grass colour, as seen in the foreground, will produce the required result and create the feeling of distance.

Using a colour index

Now that you've begun to really think about colour, you will banish the notion that sky colours are just simple mixtures of blue and white. In general, you will find that the first shock will come when you realise how much darker the sky is than you had imagined it to be. If you actually match colours on the index and then mix and use them in your painting, your landscapes will suddenly come to life.

Sunshine touching the landscape below the sky needs terrific contrast in order to dazzle the viewer. Here's how to do it using an index and your powers of observation:

Pick out a shade of blue sky starting as high up above you as you can and find the colour in the index which is nearest to what you see. Shuffle the index card at arm's length until it 'disappears' into the sky above – the two colours should be almost indistinguishable from each other. (I find it's best to have the sun behind me and one eye shut to do this.)

Having made a note on the index, drop your gaze to the sky lower down and repeat the experiment. Do this four times, ending with a careful analysis of the colour of the sky just above the horizon.

Try this on a cloudy day or in the fog. Try it when you're on holiday in different environments to compare with your local colours. Try it with anything and everything. It is the perception of changes in colour which is really the whole nature of realistic painting; quality of light can be achieved by developing this simple technique of observation.

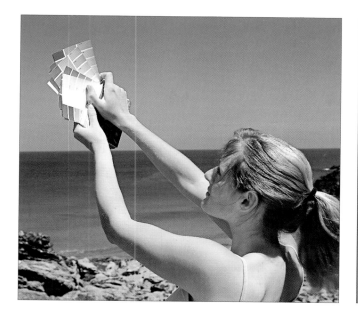

1 Hold the index cards up to the sky and spread them out so that they are lit by sunlight. You should be able to narrow your selection quickly to colours that are approximately right.

2 **By comparing the colour of the sky you see beyond the index card with the card itself, you will soon establish the sky's true colour.** Simply mark the colour on the index card with a pencil or sticker.

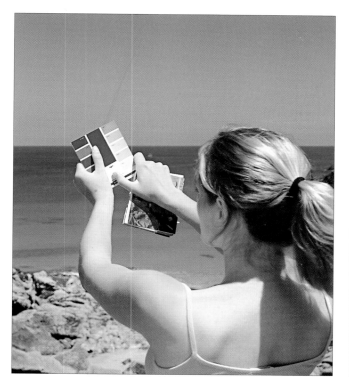

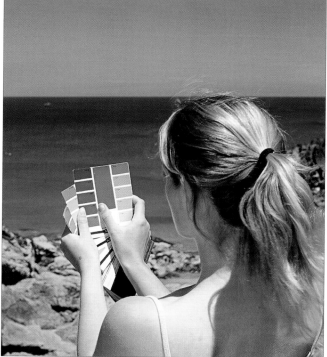

3 Examine the colours you see in other places – in this case the sea near the horizon. Discovering the truth about colours for yourself is fascinating and very exciting. You will be amazed at how using realistic colours can transform the quality of your landscape painting.

4 Pick out areas that strike you as important. **Building up a picture of the whole landscape in colour takes a little time, but helps you to have a certainty which gives you confidence.**

Exercise 26:
Learning to mix colours

If you haven't had much experience with colour mixing, don't be frightened. Try something simple at first, like one of the sky colours you have spotted using the index. A palette of the principal colours I like to use is shown here. From this selection virtually all other colours can be achieved. Using so many different colours is a bit like having lots of different herbs and spices at your disposal when cooking. The greater the variety you have, the more likely you are to give food an interesting flavour. Only experience gained by trial and error will teach you how to add things to make something more interesting.

Putting the colours on the palette in the order they appear in a rainbow helps to soften the lines of demarcation between colours – for example between blue and green or between red and orange. Psychologically, this helps with mixing, as your eyes don't have to make leaps across the palette. To remember the colours of the rainbow I always keep 'Richard Of York Gave Battle In Vain' in my mind – red, orange, yellow, green, blue, indigo, violet. This simple mnemonic gives you a masterplan for your range of colours. Additional colours can be added in the appropriate place between the basics. Alternatively, you might consider doing as I do: putting the browns near the reds at the beginning and the white – as it is not really a colour but is essential to your palette – by itself in the corner.

Always start the mixing with the main ingredient, i.e. the paint that is closest to the colour that you have spotted. For example, if

1 raw sienna 2 yellow ochre 3 raw umber 4 burnt umber 5 burnt sienna 6 crimson or magenta (I often use quinacridone crimson) 7 cadmium red medium (a mid-red) 8 cadmium orange 9 cadmium yellow medium 10 permanent green light 11 Jenkin's green 12 phthalo green (blue shade) 13 ceruleum blue 14 cobalt blue 15 ultramarine blue 16 Payne's grey 17 dioxazine purple 18 light violet 19 white

you were trying to arrive at the colour of the sky shown on page 71, start with ultramarine blue with a little white and add some Payne's grey. Then try a touch of phthalo green and maybe burnt sienna. As you can see, a plain combination of blue and white would not have done the job. Keep putting a tiny spot of the colour on the sample you've selected in the index until you get an exact match.

Practising colour mixing using photographic reference

Using photographs to work from doesn't give you the truth about colour but it's a marvellous second choice and a great way to practise your mixing skills. In order to really get to grips not just with aerial perspective but with all colour as you see it, and to learn not to take it for granted, this exercise can be repeated as many times as you want. You will always learn something new.

A good way of looking at this is to ask yourself if the colours are effective in the

photograph? Are they what you want? Do they show the right balance of contrast? Cameras and film are very inadequate in their recognition of colours compared with your eyes. This can best be judged by being inside a room and looking out into daylight. Without special artificial lighting, a photograph would not show the colours of the interior and the bright light outside. It would show darkness inside if correctly exposed for the outside or conversely, if exposed correctly for the inside, the outside would be 'burnt out'.

1 Cover your photograph with a clear plastic sleeve. Imagine that the clear plastic (use only a single thickness) is the glass through which your subject is being observed. Perhaps start with the top of the sky. Put a small blob of the nearest colour from your palette on to the mixing area. Gradually, in very small amounts, add colours to the original blob, which change it to something nearer your true perception of the sky's colour.

2 Paint on to the plastic sleeve. When a small blob of colour seems to 'disappear' into the sky on your photograph, you are mixing the hue you want. It may take several attempts to get it right and the final result may include some very unexpected ingredients. Move down the sky, mixing, blending and experimenting.

3 When you get to the landscape, carry on without letting yourself have any preconceptions of what colour things should be – just let yourself discover what they actually are. Matching perceived colours in this way quickly teaches you to recognize various tints and, with practice, you won't need a plastic sleeve for long! This is a sort of personal painting-by-numbers but keep in mind that these paintings have been fantastically popular for decades. Why? Because they give inexperienced artists confidence with colours and shapes.

Some examples of aerial perspective

Even the most closely viewed subjects are affected by aerial perspective. Learn how to spot really small changes in colour as objects recede from you. Even something seen on the other side of the street will have had its colour slightly changed by aerial perspective, especially on a foggy day. Remember that the elements in your painting that are nearer should be stronger in colour, with more contrast between light and shade. Learning to use aerial perspective will give you every chance to produce marvellous realism in your work.

◁ ◹ ◺ (*Tuscan View* by Janet Shearer; 2.5 x 1.5m/ 8 x 5ft.) You can create a feeling of distance in your painting simply by flicking a fine spray of sky colour over the hillside near the horizon. Several fine sprays will be more effective than one heavy one and this way you can watch the result develop slowly (see pages 68–69).

⌂ Here we can clearly see the subtle change of colour between the foreground and the distance. You will see that the change isn't just a question of making the background lighter, so using your colour index may really help to analyze the colours you need to mix.

⌂ (*The Monk* by Janet Shearer; 2.5 x 1.5m/8 x 5ft.) This painting has many layers of toothbrush-applied paint.

⌂ The changes of colour caused by local atmosphere vary in different parts of the world. In this photograph, notice how blue the more distant hillside has become. Strong ultra-violet light has caused this.

Foreshortening in Figurative Drawing

There is another kind of perspective which does not necessarily involve straight lines, but which can be better understood now that you have a clear idea of eye-levels and vanishing points. Learning to 'see' awkward shapes, such as people and animals, as they appear on the picture plane is the essence of drawing well. You need to recognize what you are seeing as a series of curved lines which change direction.

Many people have difficulties when faced with a complex shape like this horse. Our eyes enable us to understand what we are looking at, but our brains become confused when we try to put it down on paper. It's a question of trying to forget the name of the subject and following only the shape on the picture plane.

Foreshortening of live forms

When you draw animals or people, it can be much more difficult to 'flatten out' the image on to the picture plane, because you think the shapes are so complex. Here are a few tips which you might find helpful.

If you looked at a horse from the side (above right), you would be unaware of any foreshortening and would see the whole body in a way that shows the normal equine proportions (although if you really thought about it, you would notice that the hooves which were furthest away from your viewpoint are apparently slightly 'higher' on the picture plane than those which are nearest).

If you looked at a horse from the front or back, from above or below, its elongated body would appear squashed into a shorter shape on the picture plane (centre right). This is due to visual perspective. Part of the horse is further away and therefore smaller as perceived on the picture plane. Quite often, it seems difficult to understand what you are seeing and many budding artists give up at this point, but it isn't as impossible as it seems. You now need to call upon everything that you have learnt so far in order to understand this image as it appears on the imaginary glass picture plane.

It can help to draw a box in exactly the same way as you did with the buildings (below right). Learn to recognize where your own eye-level is in relation to the position of the horse and draw the horse inside the box. By using chosen vanishing points, you can quickly see the relationship between the different parts of the horse's body and in your

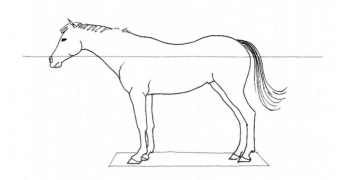

⌂ Seen from the side, hardly any foreshortening appears to affect the shape of the animal.

⌂ When the animal stands at an angle to the picture plane, its body is foreshortened – i.e. squashed – as it appears on the imaginary glass in front of you.

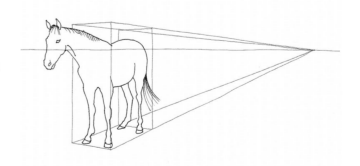

⌂ When viewed from an angle the same horse's body can be put in a box and the box can be drawn using vanishing points in the usual way.

drawing/painting he will stand, sit or lie firmly on the ground in a convincing way. Learning to see what shape his body has become is

more difficult, but my advice, in very simple terms, is to try and ignore the horse altogether and draw only the spaces left around his body by comparing the directions of your drawn lines with angles that you know and recognize; i.e. horizontal, vertical and 45 degrees. It may help to stretch your arm out in front of you and use a pencil to isolate these specific angles.

Difficult foreshortened shapes, such as this foal that is lying down (below), become much less daunting when you only concentrate on the negative shapes – in other words, the shapes that appear on the picture plane which are not occupied by the subject.

⌂ Looking at a really complicated shape like this foal lying down needn't be daunting.

Using your pencil held vertically at arm's length as before (see pages 24–25), you can also measure distances between different parts of the body (right). This will help you enormously. Compare heights with widths and ask yourself how many times one part of the body (for example the head) fits into another. Try not to see what you believe, but believe what you see. You will be amazed at your capacity to fool yourself and only by forcing yourself to be truthful about what your eyes are telling you, will you be able to progress your drawing skills.

A drawing tip

If you forget the name of what it is you are drawing and concentrate instead on letting your eyes digest the actual shape – you will be surprised at how much easier it will be to make your drawing look competent. Frequent drawing practice will help to assess angles and shapes so that you can transfer your observations on to the paper more easily.

Don't be afraid to copy from photographs if you don't have access to a subject that appeals to you artistically. When copying from a photograph, try turning the photograph upside down to copy it. As soon as your brain is tricked into not recognizing what it is that you are trying to draw, you will find drawing the actual shapes of the image much easier. This will prove to you that you must persuade yourself to let go of any preconceptions that you have about shapes.

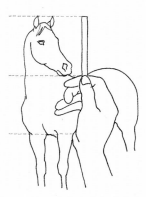

⌂ Using the pencil-measuring method can help to work out the right proportions as they appear on the picture plane when you are drawing an animal from an angle.

Exercise 27: Drawing figures in proportion

During our normal, everyday activities it is our incredible eyes and brain which describe to us what we are seeing. The ability to translate these images onto the picture plane means that you have gone beyond the 'everyday' and that you are starting to look at things as an artist. The prospect of drawing the human figure becomes much less daunting when you have access to a little more information.

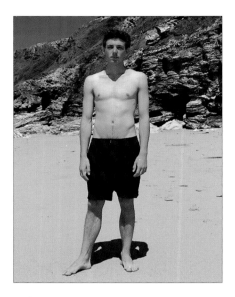

1 **Always assess your eye-level in relation to your subject.** This standing figure was photographed from a normal eye-level: i.e. about 1.5m (5ft).

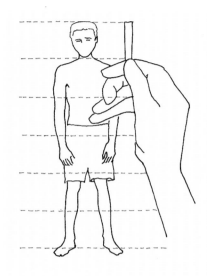

2 Use the 'measurement' of the head as a unit of one. See how many heads fit into the rest of the body.

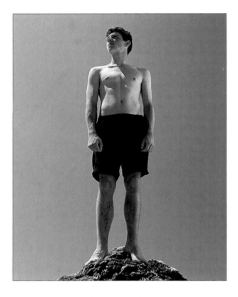

3 Repeat this exercise, now viewing the body from low down. Of course, because the head is so much further away from you it is much smaller.

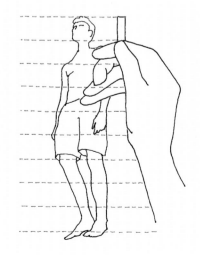

4 Again, using some extra knowledge, you have the ability to assess size and advance confidently with the drawing.

5 Try looking at a figure lying down – from the head end. The figure is very foreshortened by perspective.

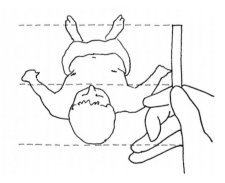

6 You will see that there are only two 'heads' in the whole body! It can be difficult to convince yourself of what you are actually seeing.

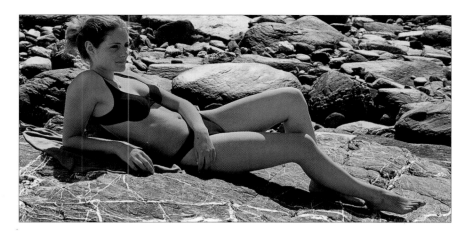

1 Now have a look at the girl lying down. This photograph is taken from the side, so like the horse at the top of page 78, the proportions are normal.

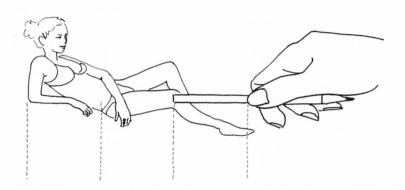

2 Using, for example, her leg, from the knee to the foot as a unit of one, you can see that there are just under three 'units' of leg in the entire length of her body.

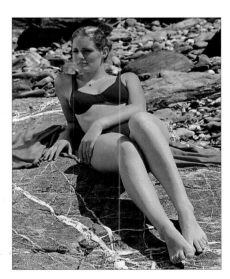

3 When you change your viewpoint and move round to look at her from the front, that same length of leg occupies almost twice the space of the rest of the body altogether.

4 What you choose to use for your unit of measurement is entirely up to you. Drawing is a very private language that you only have to speak with yourself, so don't worry if your choices seem absurd, no one will ever know.

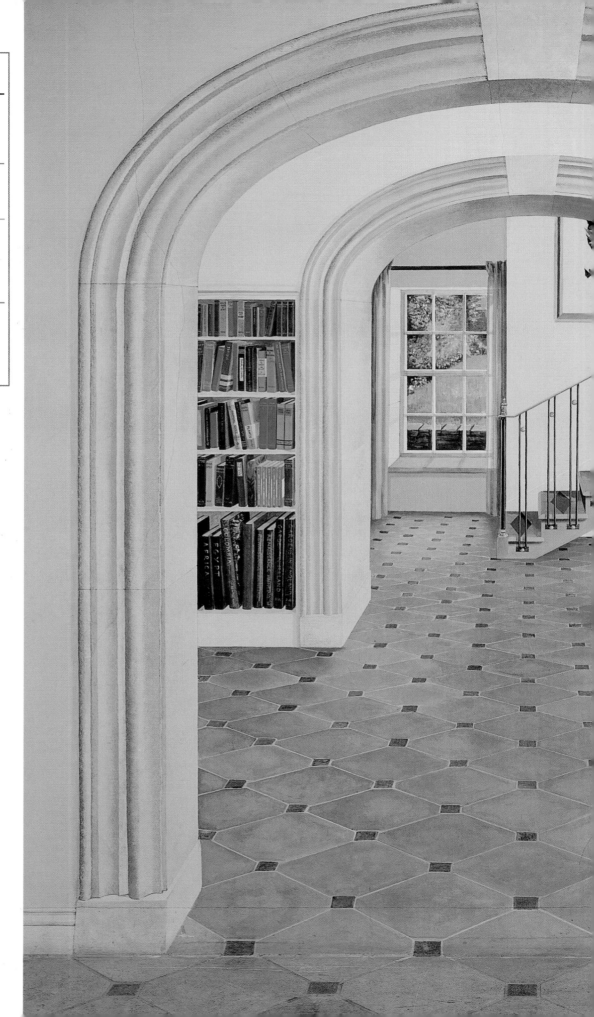

Key

Black lines: lines as viewed in real life

Red lines: eye-level

Blue lines: drawn lines on picture plane

Green lines: important 'construction' lines

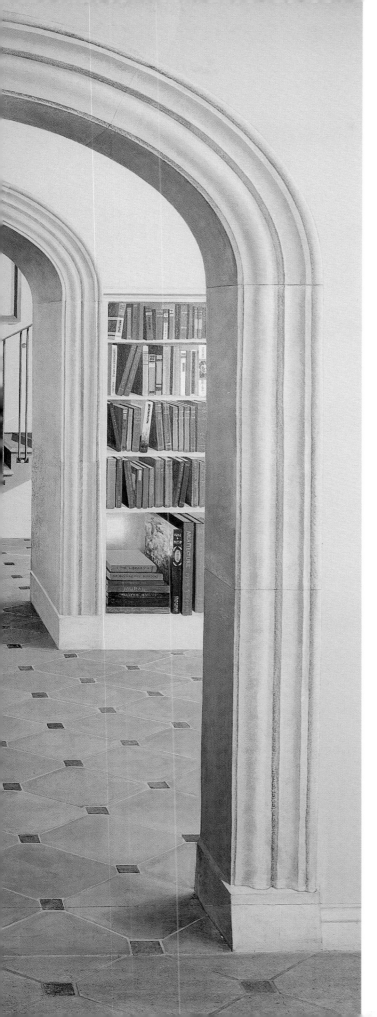

More Advanced Perspective

I n most instances when drawing or painting, eyeballing the subject is all you need to do. I have not often found it necessary to be completely accurate, but it is useful if you know how. Technical drawing is more precise than eyeballing and in this chapter I have set out simple guidelines on how to be a bit more accurate when you want to represent exactly how your subject appears from a particular eye-level and viewpoint on the picture plane.

Sometimes knowledge of perspective during a painting project can be enhanced by touching on the subject of technical drawing using plans and elevations. This mural made full use of everything mentioned so far in this book – and a little more – which is outlined in this chapter. If you have the interest, there's no need to stop here!

Understanding scale

Scale is a way of reducing real-life measurements from their true size down to a manageable size in order to represent them on paper. This is done using a scale ruler.

Different scales are marked on the ruler: for example 1:5, which means that one centimetre on the ruler represents five 'life-size' centimetres. You might choose to use this scale if you had a large piece of paper and the subject itself was quite small: for instance, a cardboard box. A smaller scale, such as 1:10 or 1:20, could be used to show a larger subject in the same space on the paper: for example a room or a small building. When you are drawing a subject covering a really big area, a street plan for example, you might use 1:100, 1:250 or even 1:2500.

⌂ Drawing to scale is done using a scale ruler, which converts measurements from their realistic value down to a practical size for the paper which you have available for your drawing.

Plan and elevation

A plan is a bird's-eye view of a subject showing the main features drawn to scale. You can make a plan of either a real or an imaginary area. An elevation is a flat view of the subject as it faces you square on. An elevation can be done of any side of a subject, for example, the faces of a building or the four walls of a room.

In the case of my mural design, the picture plane is the wall and so this itself becomes the elevation. With interior design, architecture or other painting projects, the picture plane is the paper or canvas upon which you intend to work. You can 'place' the picture plane in any position depending on the size of your drawing or painting. Consider that you have a 'field of vision' which can be shown on the plan, usually contained within 60 degrees. Where the edges of your field of vision touch the picture plane, you have the edges of your drawing or painting, and therefore your picture plane is contained within this area. This is your sheet of glass.

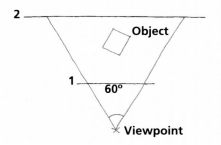

⌂ The picture plane is always at right angles to your direction of view. You can position the picture plane wherever you want within your field of vision. If it is between you and the object in your view (1) the image appears smaller than the object as shown. Conversely, if the picture plane is beyond the object (2), then the image is enlarged.

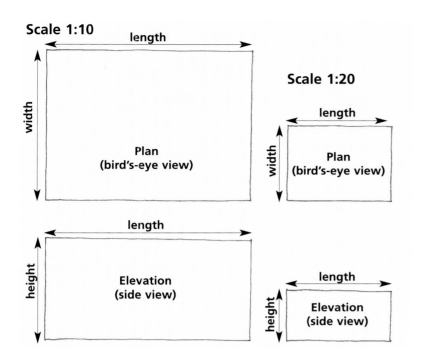

Scale 1:10

length

width

Plan
(bird's-eye view)

Scale 1:20

length

width

Plan
(bird's-eye view)

length

height

Elevation
(side view)

length

height

Elevation
(side view)

◊ This shows a plan and an elevation in two different sizes, proportional both to the life-size object (a cardboard box) and to each other. One of them is twice the size of the other. The plan shows the dimensions of the box as seen from above. The elevation is a view of the subject as if seen absolutely square on from any chosen point, also showing its dimensions in the same scale as the plan. In this drawing the box is seen from the side. Both were drawn with the use of a scale ruler.

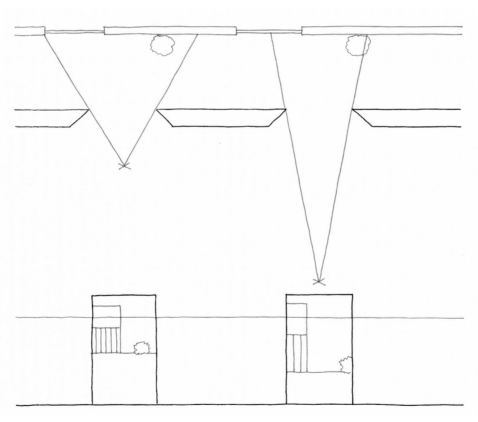

⌂ The best way to understand what is meant by field of vision is to stand centrally in front of an opening in a wall: for example a door or window. Observe the view that you can see through the opening, then take two or three big steps backwards and look again. You will notice that although your eye-level has stayed constant, i.e. in the same position in relation to whatever it is you are looking at, the position of other elements enclosed within the frame of the door or window will have apparently changed. You will see a narrower view of your subject than when you stood nearer to the opening. This explains why, in the following exercises, it's important to establish the position of your viewpoint in order to be accurate.

Exercise 28: Using a simple plan and elevation

The following is a technical way of using information that you have – heights and distances – to make a perspective drawing. Although eyeballing subject matter is perfectly adequate for most drawing and painting projects, here is a way of being more certain about the exact position of vanishing points and the exact shape of the final perspective drawing. The eye-level and distance from the picture plane are very important and critical to the accuracy of the final result. When you have mastered the simplest of shapes drawn from a plan, try experimenting with more complex subjects. This part of the book aims to explain the principle. You can expand your own horizons as you feel more adventurous.

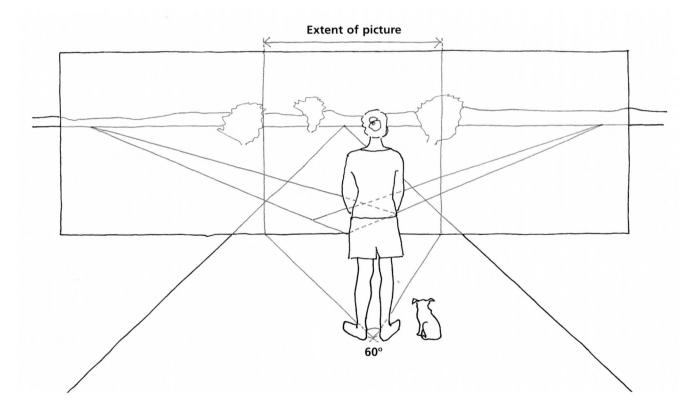

1 Try to imagine that you are standing in the road as before. In front of you is the picture plane and beyond it, on the road, is an outline of where the box stood. This outline is a plan: i.e. if you were to have looked at the box from above, this outline is what you would have seen. You know how to find the vanishing points for the sides of the outline (see pages 22–23). The girl has her feet turned parallel to the sides of the box – in case you need reminding.

2 From above you would see the girl standing at her viewpoint, the picture plane and the plan of the box as shown. In this case, the corner of the box is actually touching the picture plane and the extent of the picture within the field of vision is shown. Everything beyond the field of vision will be slightly distorted.

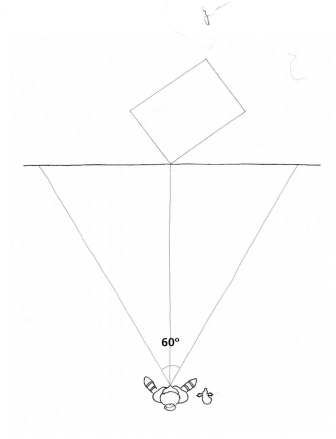

60°

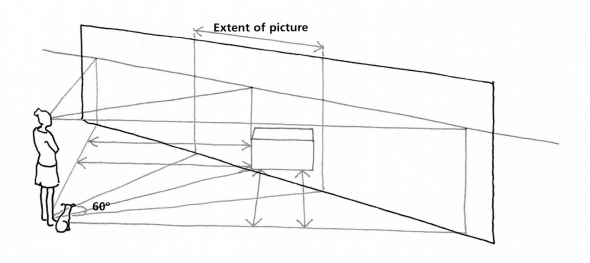

Extent of picture

60°

3 Here she is again, showing the box on the other side of the picture plane, with the eye-level line marked on the picture plane and the vanishing points shown marked on the eye-level. The green lines to the vanishing points are parallel to the sides of the box. The corner of the box is touching the picture plane in the centre, so I have marked the centre as well.

(Sequence continues on page 88.)

4 The footprints of the girl (and the dog) are shown in this drawing. Remember that where they are is the viewpoint. In order to continue with this drawing, imagine you could pull the picture plane towards the viewpoint, allowing sufficient distance from its original position to flop it down flat on the ground in front of the viewpoint, without getting muddled up with a line showing its original position and the position of the box marked on the road. The eye-level (shown in red as usual) and the position of the vanishing points on it have remained stuck to the surface of the – now flat – picture plane.

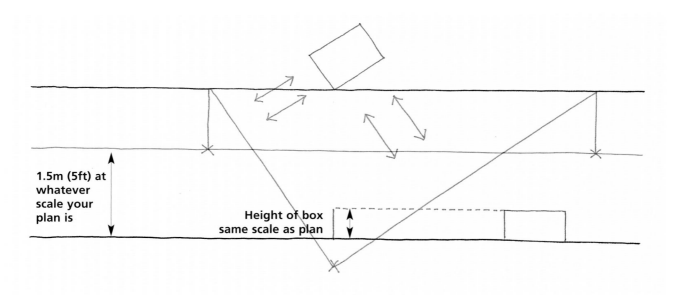

1.5m (5ft) at whatever scale your plan is

Height of box same scale as plan

5 In this drawing, the important facts have been preserved. A cross marks the viewpoint. The ground line, or base of the now flat picture plane, is shown in black and the original position of the picture plane is also marked. The green lines, parallel to the sides of the box, have travelled up to the original picture plane, then vertically down to their new position on the eye-level in the now flat picture plane. Also marked on the ground line is an elevation of the box, showing its height and width. I have marked its height on the centre line where it would appear to be its full height in the final drawing.

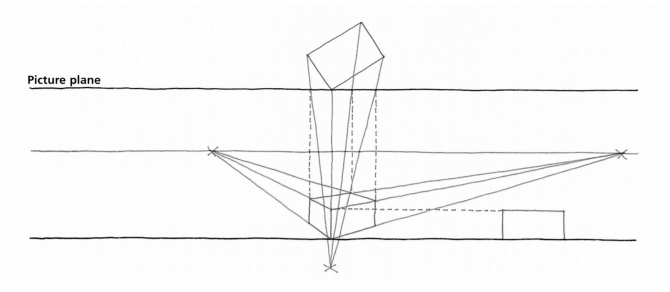

Picture plane

6 Now it's just a question of joining up the dots. By connecting the corners of the plan of the box with the viewpoint, you can establish the positions of the verticals in perspective. Where each line crosses the original position of the picture plane, drop vertically

downwards on to the, now flat, picture plane, as shown. Draw lines from the top and bottom of the corner of the box, which we marked in the previous diagram, to the vanishing points. The box appears – perfectly in perspective. Try it for yourself.

Changing your viewpoint

Changing the position of your viewpoint and the height of your eye-level alters the final result. This very simple example illustrates what happens.

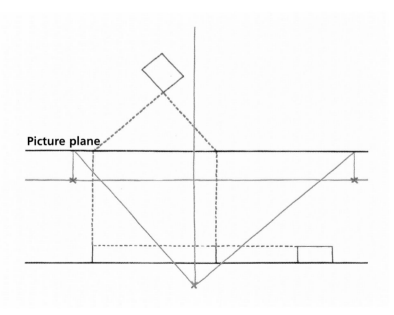

Picture plane

1 In this diagram, the box is not in the centre and is not touching the picture plane, but we can use all the tricks we have just learnt to locate the box in the right place on the picture plane. I have also made the eye-level higher than it was previously.

As before, the viewpoint is marked with a cross and the vanishing points marked parallel to the sides of the box in the plan. This time I have extended the sides of the box to meet the picture plane and marked on the ground line below where these sides would appear at the same scale as the plan.

Using an elevation of the box, also drawn on the ground line, I have established what size the box would be at these points.

(Sequence continues on page 90.)

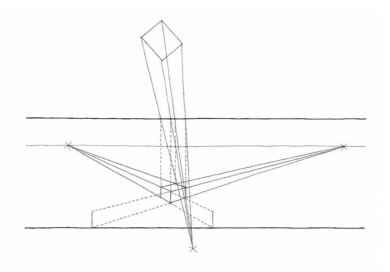

2 Now you can link these two 'full-size' corners to the vanishing points on the eye-level and locate the verticals in the same way as we did with the first box. As you can see the higher eye-level means that you see more of the top of the box.

Exercise 29:
From a box to a window

Using the method described on pages 86–89, you can draw absolutely anything you want in perspective – doors, windows, interiors, buildings, whatever. This exercise is another very simple example which shows a way in which I have used this method: drawing an open window on a wall. In this case the wall itself is the picture plane and, because the drawing would eventually be transferred from paper to the wall, using scale was very important to enable me to measure the position of everything accurately so that I could mark it out life-size. I wanted to know exactly where the verticals would be and also the angles made by the top and bottom edges of the open window from a comfortable viewpoint.

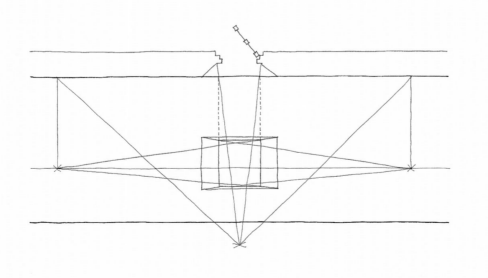

1 From my chosen viewpoint I drew lines parallel in the plan to the angled side of the window recess. As a result, I was able to locate the vanishing points for these edges on the eye-level and draw them correctly on the eye-level below.

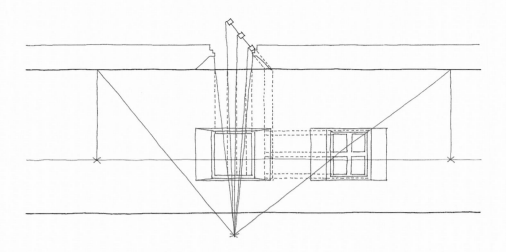

2 Next I drew lines parallel to the edges of the open window in the plan – both the longer face of the window and the perpendicular edges, which are very short but very important to the final result (see page 51). I drew an elevation next to the position of the full size window opening so that I could use the position of the window's edges and glazing bars extended horizontally sideways to guide me in the perspective drawing as shown.

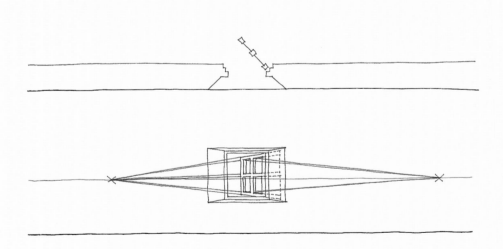

3 As before with the box, which was set back from the picture plane, I extended the window drawing in the plan to touch the picture plane. In this way I could establish its full size and complete the drawing by using the vanishing points, carefully connecting each relevant vertical.

The Arches

My mural is another example of how to use a simple projection from a plan to create the illusion of space in a painting. Here, my brief was to exaggerate the feeling of space in a small room by painting a mural using the perspective of the real stone floor tiles to hide the division between reality and illusion. This would not have been possible to do precisely without the benefit of some knowledge of how to use perspective to my advantage.

Firstly, I had to compose the painting, which was loosely based on a photograph I had seen of a library in a stately home. The room in which it was to be painted was quite small and also had rather a low ceiling, which is why I had to make the painted arch elliptical rather than semi-circular, which would have required much more height.

My first consideration was the viewpoint – the position of the spectator in relation to the wall. If you remember, when you looked through the open door from different positions (see page 85) you discovered that the closer you stood to your subject the more you see through the opening. As the size of this room did not allow the spectator to stand very far away from the painting, I decided to use a little artistic licence here and pretend that I could stand further away than was actually possible. This meant that the distortion would be lessened

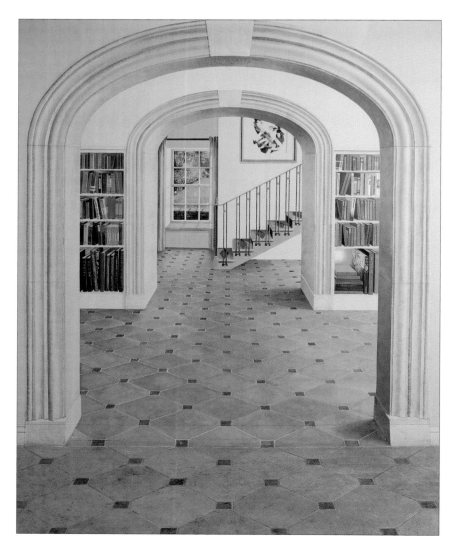

◊ (*The Arches* by Janet Shearer; 2.5 x 2.5m/8 x 8ft.) As you can see from this photograph – which was taken from the correct viewpoint, at the correct eye-level – I have proved that perspective drawing from a plan works!

and the view through the opening limited.

Having made plenty of rough sketches to work out what I wanted to show in the painting, I started to make a plan of the imaginary room, using a suitable scale, leaving space underneath so that I had room for the perspective drawing. Measurements in the imaginary plan were eyeballed, using a tape measure and an open bit of floor space to try and guess how big the 'spaces' shown in the imaginary room might be. I put all of the elements unaffected by perspective into the drawing to start me off. In other words, if you try to imagine the glass picture plane, anything which appeared on the glass itself and was to remain life-size.

The first and most important line – the eye-level – was drawn in at a height of 1.5m (5ft). To draw the arch on the picture plane, I had only to make some life-size measurements of how big I wanted the opening to be using a tape measure. Then, by using scale, I reduced the arch on to my paper, putting it in the correct position. The curve of the arch was actually drawn using the method on page 55, but for the scale drawing a sketched curve would do, remembering that one side is a mirror image of the other.

The next thing was to use the plan to find the positions of verticals and vanishing points.

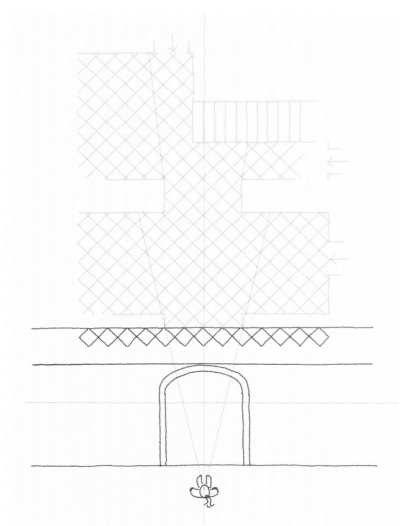

1 The chosen viewpoint is clearly marked on the plan, its position measured to scale from the picture plane. To save space, the viewpoint appears below the perspective drawing, but if I'd had a large piece of paper, I could have done the perspective below the viewpoint. The green lines show the extent of the view through the opening – in other words, the apparent view that the spectator would be able to see through the imagined arch. The floor tiles, which in real life were set at 45 degrees to the wall, are also shown: the real ones in black and the imaginary ones in blue. When doing a drawing like this, you need to make sure that both the eye-level line and the picture plane line are extended far enough out to the side to give you room to find the vanishing points on them.

(Sequence continues on pages 94–95.)

All the information was there, I simply needed to construct the perspective drawing.

Refer to page 54 to remind yourself why the arch was initially drawn as if square. The apparent depth of the arch seems thinner at the top than the sides because the top of the arch is quite low and therefore near to the eye-level. Once I knew the new position of the point from which the arch springs – in other words where the curve begins – and its new height, I used the method shown on page 47 to draw it using a major and a minor axis, the major axis being the width and the minor axis the height.

To find the new positions of the verticals I connected the viewpoint to points of intersection in the plan as before. The point at which the connecting line crosses the picture plane shows the position of the vertical in the perspective drawing. This position was dropped vertically into the drawing below.

Completing the drawing was now more or less a question of joining up the dots. The three vanishing points, i.e. the two for the sides of the floor tiles and the central vanishing point for all lines parallel to the direction of view, now make the drawing come to life. I could start the edge of each tile from a point marked on the picture plane which was easy to establish by measuring where the

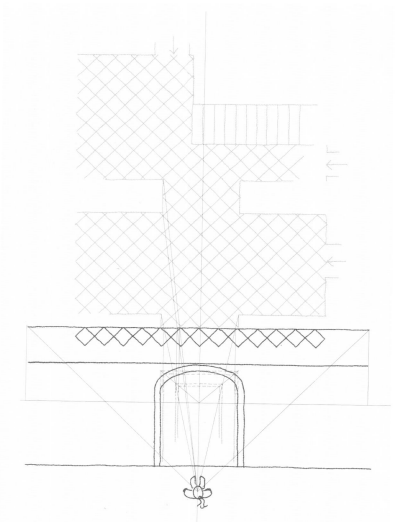

2 If I had been eyeballing the position of the vanishing points for the floor tiles, which were set at 45 degrees to the picture plane, I could have angled my feet to 45 degrees (they would have ended up at right angles to each other), lined my arms up with my feet and pointed to the eye-level. However, in order to find the exact position, I drew two lines on the plan from the viewpoint to the picture plane, which were exactly parallel to each of the sides of the floor tiles. From the point where they met the picture plane I dropped vertically down to the eye-level line in the perspective drawing and then could mark the exact positions of the two vanishing points for the sides of the floor tiles. These would be at equal distances from the central vanishing point because the tiles are set at 45 degrees to the picture plane.

tiles touched the wall and marking that spot on the plan. Corresponding points on the ground line below could be connected to the vanishing points as shown, describing the floor accurately. To enable me to complete the floor in the distance, I needed to make many more marks sideways along the ground line than the few contained within the arch. The diagonals of the tiles should converge at the central vanishing point.

3 To transfer the drawing from paper to wall was simply a question of measuring reference points in the scale drawing and then converting this measurement back to life-size on the wall. For example, if you wanted to establish the position of the nearest corner of the distant arch, you could measure on the drawing using a scale ruler from the ground line upwards and from the side of the main arch, then do the same with a tape measure on the wall itself.

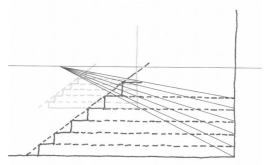

4 I marked out the outline of the stairs to scale on the elevation. Note the angle at which the staircase rises. I drew lines from the intersections of treads and risers back to the central vanishing point. Returning to my plan, I found the position of the staircase in my painting by establishing important points as before. I started with the bottom step and once this was in place, the rest followed. The staircase in my 'view' followed the same angle and each step had the same dimensions as the first. Stairs rise at a constant angle, usually 35–40 degrees.

INDEX

Further Reading

Edwards, Betty *The New Drawing
on the Right Side of the Brain*
(HarperCollins, 2001)

Norling, Ernest *Perspective Drawing*
(Walter Foster Publishing Inc.,
1997)

Smith, Ray *An Introduction to
Perspective*
(Dorling Kindersley, 1999)

White, Gwen *Perspective: A Guide
for Artists, Architects and Designers*
(B. T. Batsford, 1989)